SCENES AND SEQUENCES

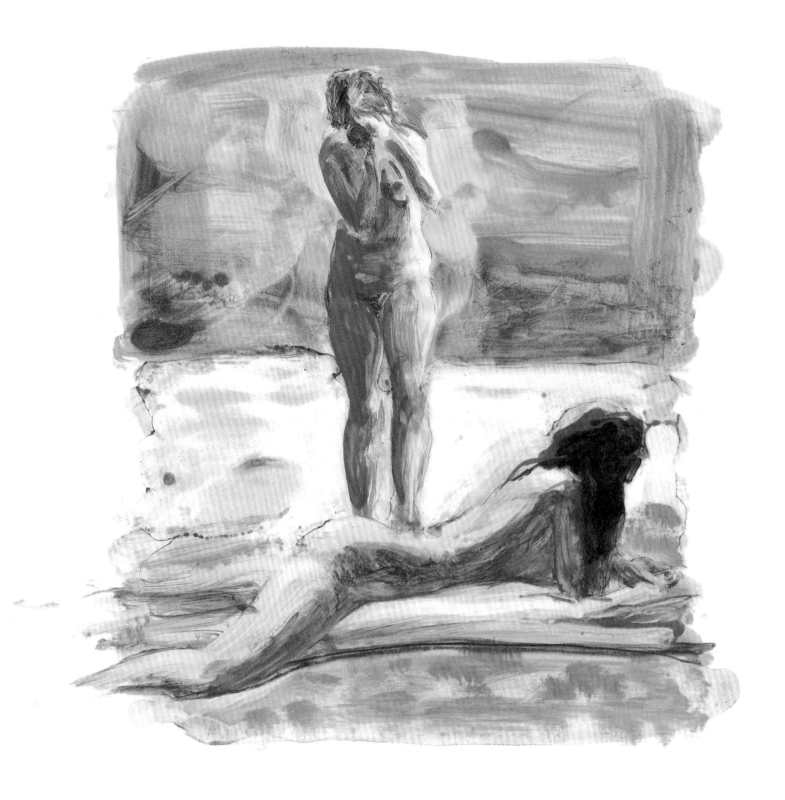

Dream

Major support for this catalogue has been provided by
The Douglas S. Cramer Foundation and the LLWW Foundation

SCENES AND SEQUENCES

Recent Monotypes by Eric Fischl

HOOD MUSEUM OF ART · DARTMOUTH COLLEGE · 1990
Distributed by Harry N. Abrams, Inc., New York

© 1990 by Trustees of Dartmouth College
All rights reserved
Hood Museum of Art
Dartmouth College, Hanover, NH 03755

LIBRARY OF CONGRESS CATALOGING-IN-PUBLICATION DATA

Fischl, Eric, 1948–
 Scenes and sequences : recent monotypes by Eric Fischl.
 p. cm.
 Includes bibliographical references.
 1. Fischl, Eric, 1948– –Catalogs. I. Hood Museum of Art.
 II. Title.
 NE2246.F5A4 1990 89–71665
 769.92–dc20 CIP
 ISBN 0–8109–3303–9 (Abrams)

Reproduction credits: Zindman/Fremont, for all monotypes from the *Scenes and Sequences* project with the exception of catalogue numbers 66, 83, 94, 113, 116, 121, 135, and 141 which are courtesy of Derrière L'Etoile Studios and catalogue numbers 67, 72, 77, 80, 130, and 139 which are courtesy of G.H. Dalsheimer Gallery. Rolan Gretlier, Zurich, page number 57.

E.L. Doctorow's text is reproduced with permission of the author and Peter Blum Edition, Blumarts, Inc., New York.

This book has been published in conjunction with an exhibition of the same title. Exhibition schedule: Grunwald Center for the Graphic Arts, University of California, Los Angeles, April 3 – May 13, 1990; Walker Art Center, Minneapolis, July 29 – October 21, 1990; Yale University Art Gallery, New Haven, November 6 – January 10, 1991; Hood Museum of Art, Dartmouth College, March 9 – May 19, 1991.

CONTENTS

Dream 3

Introduction and Acknowledgments 11

Stroll 13

These beings / Spraddling the dunes . . . 20
E. L. DOCTOROW

"A kind of accomplice in it, an unwilling witness to the event" 21
JAMES CUNO

Backyard 25

The Dreams and Lies of Eric Fischl's Monotypes 33
RICHARD S. FIELD

Voodoo 45

Eric Fischl's Monotypes: In the Continuum 55
ELIZABETH ARMSTRONG

Private Pleasures: Fischl's Monotypes 63
CAROL ZEMEL

Beach 67

Catalogue and Checklist 77

INTRODUCTION AND ACKNOWLEDGMENTS

In March 1986, at the invitation of publisher Peter Blum, Eric Fischl began making monotypes in the workshop of the printer Maurice Sanchez. Over the next nine months, Fischl explored thirteen narrative subjects for which he eventually produced 144 monotypes. From these, Blum chose fifty-eight for reproduction in a deluxe facsimile, book-length publication of the thirteen monotype series, entitled *Scenes and Sequences*.

During the same period, Blum approached E.L. Doctorow and proposed a commission of a non-fiction text to be included in the publication. Blum had in mind, perhaps, a series of short prose pieces that could be interspersed between the monotype series; something like the prose pieces that comprise Doctorow's 1984 book, *Lives of the Poets*. Doctorow was familiar with and admired Fischl's paintings, but had not yet seen the monotypes. After seeing them in the spring of 1987, he agreed to the commission, although at the time he had no idea what kind of text it would be and could not turn his attention to it until he had completed his novel, *Billy Bathgate*, which he only did more than a year later. Then, working from a complete set of facsimile reproductions, Doctorow set to work and, in April 1989, offered Blum the text which, with a few changes by the author, was published in *Scenes and Sequences* the following December.

We were shown the monotypes in Fall of 1988 and saw immediately that they represented the artist's most important graphic work to date. Within weeks we began organizing the present exhibition and preparing its accompanying catalogue.

We chose to limit the exhibition to the monotypes reproduced in *Scenes and Sequences* because for all intents and purposes it is by the facsimile edition that the entire monotype project will be known. Very soon after they were released, all 144 monotypes were dispersed among several public and private collections and their relations to each other within the thirteen narrative series of the original project lost. Therefore,

we have dedicated the exhibition catalogue to the facsimile edition, to how it directs the reader through the monotypes in a certain order, and to its place within the larger context of Fischl's other prints and paintings. In this respect, it should be noted that as editor Peter Blum selected the fifty-eight monotypes reproduced in *Scenes and Sequences*, respecting the sequence in which they were printed within each series, as well as the titles given the series by the artist, but ordering the series differently. Thus it was he who determined the structure of the facsimile edition and the placement of the Doctorow text within it. We do not wish to make too much of this point, only to clarify at the outset the role of publisher and artist and their close collaboration in the production of *Scenes and Sequences*.

We have structured the exhibition catalogue so as to direct the reader first to a close scrutiny of the images and text of the facsimile edition, and then to have him or her consider the place of *Scenes and Sequences* within the context of the entire monotype project and Fischl's art in general. Therefore, I address E.L. Doctorow's text in relation to Fischl's prints and, by so doing, bring the monotypes into relief for a closer examination by our three principal contributors. Richard Field points to the irony in Fischl's work, by which the artist carefully reveals and then obscures his intentions, forcing the viewer to recognize that it is his or her fantasies and not the artist's that are forcibly engaged by viewing the prints and paintings. Field then argues that Fischl confounds our wish to find a specific set of meanings in his work by refusing to privilege one reading over another. This strategy—which Field believes is abetted by the sympathetic technique of the monotype—undermines our identity and exposes our resistance to taking sides, to our feeling real desire and genuine compassion for others as represented by the figures in Fischl's work.

Following Field's lead, which was derived from an especially close examination of the monotypes, Elizabeth Armstrong looks beyond the prints to Fischl's paintings and argues that they are structured to leave the

viewer in a morass of social confusion and moral ambiguity. Although the artist implicates himself in the social and ethnic stereotyping of the figures he paints, Armstrong emphasizes that he offers no judgment on them. They are presented, uncensored and subjective, as evidence of his and our positions *vis-a-vis* the politics of representation. Carol Zemel's essay concludes the interpretive section of our catalogue and offers a tightly argued feminist reading of *Scenes and Sequences* and its relation to Fischl's work in general. She concludes that the facsimile edition complicates the critical effect of Fischl's more public art because it can be held and read in private. It challenges the reader's personal constructions of gender, race, and sexuality, by leaving him or her feeling comfortably detached and his or her voyeurism undisturbed.

Although there are common threads running through these essays, there are also profound and obvious differences. Field and Zemel complicate and problematize Armstrong's rather straightforward critique of Fischl's art and my wholly empathetic reading of Doctorow's text and its interpretation of the monotypes. These differences were expected and we encouraged their articulation. They were meant to elicit further discussion of *Scenes and Sequences* and to draw the reader into the insistent uncertainty that comprises the power of Fischl's paintings and prints. For, as Field put it, "one has to accept the ultimate irony that in Fischl's art the more that is known, the more remains indeterminate."

Many people contributed to the success of this catalogue and to the exhibition it accompanies. The artist and his publisher, Peter Blum, gave much of their time and energy to insure its quality; as did Maurice Sanchez, whose patience and knowledge guided Fischl through the subtleties of monotype printing, and E.L. Doctorow, whose sensitive text charged *Scenes and Sequences* with additional power and who granted us permission to reproduce his text in full. Andrea Scott of Peter Blum Edition was always available to answer questions about and provide documentation for the prints. Similarly, Mary Boone and George Dalsheimer provided valuable information on the prints in their possession or sold through their galleries.

More crucial than all of these, however, were the lenders to the exhibition. Their willingness to let the prints travel for such a long period of time was a sure sign of their generosity and commitment to the serious presentation of contemporary art. For this we thank the artist, Paine-Webber, Inc. and its curator Monique Beaudert, and Peter Blum.

I owe a personal debt of gratitude to Douglas Cramer and Laura-Lee Woods for their very generous support of the exhibition and catalogue. Their immediate and enthusiastic response to my requests permitted us to make of this catalogue a most beautiful book. Credit for the catalogue's design is due Christopher Kuntze of Meriden-Stinehour Press; his sure sense of clarity and elegance is everywhere present. I am grateful, too, for the participation of our authors, Richard Field, Elizabeth Armstrong, and Carol Zemel, whose contributions have added much to our understanding of Fischl's work.

At the Hood Museum of Art, Elisabeth Gordon managed every detail of the exhibition's organization with precision and confidence, while Rebecca Buck and Evelyn Marcus respectively executed its organization and design with distinction and professionalism of the highest degree. Nancy DeGrandpre and Theresa Delemarre oversaw the financial details of the exhibition with care. Marion Bratesman was responsible for press and public relations. And Mary McKenna provided crucial last minute administrative help. But of everyone at the Museum, Timothy Rub, Associate Director, is due our greatest thanks. He directs and administers our exhibition program and, in a year in which there were numerous, large and demanding exhibitions which took more time than even he had to give, he directed this one with characteristic thoroughness and sound judgment.

James Cuno
DIRECTOR
HOOD MUSEUM OF ART

Stroll

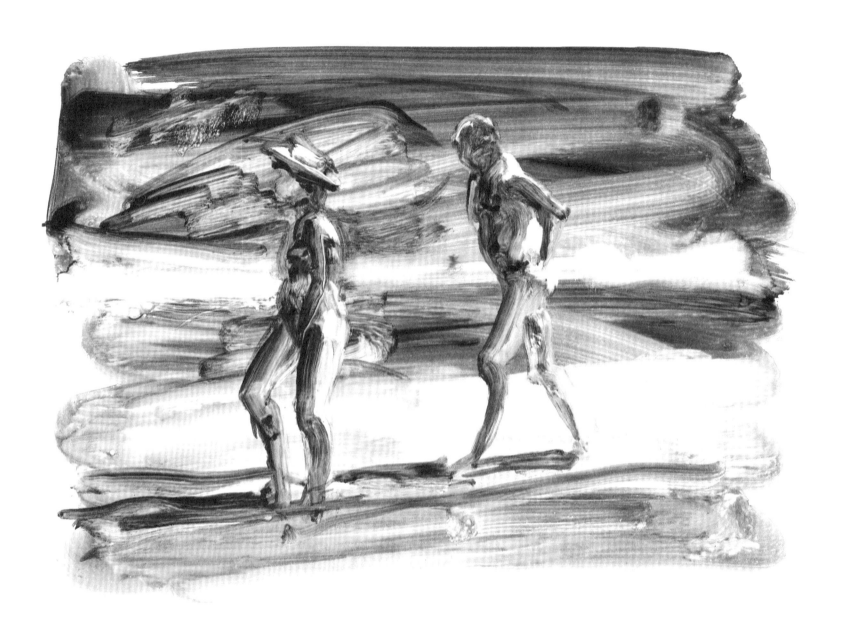

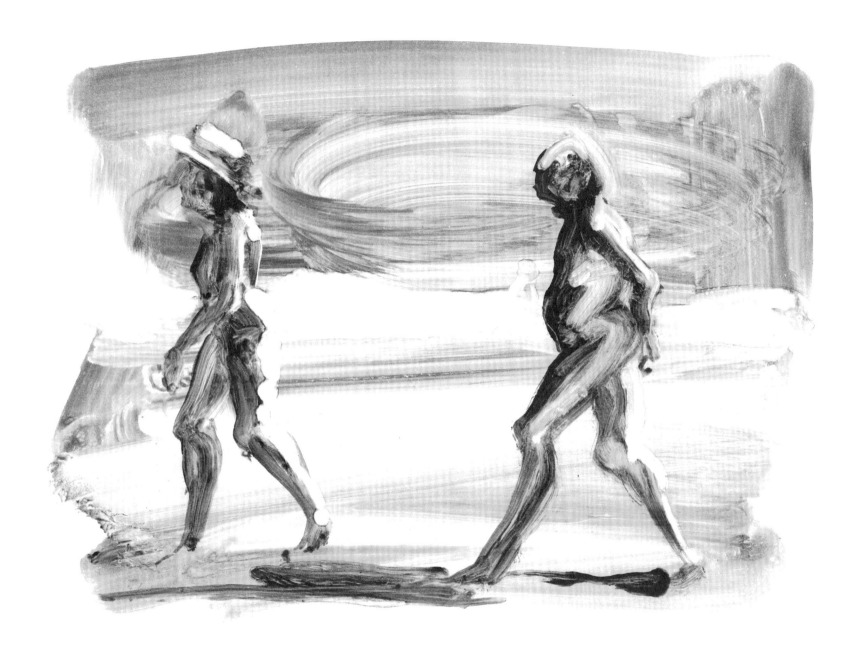

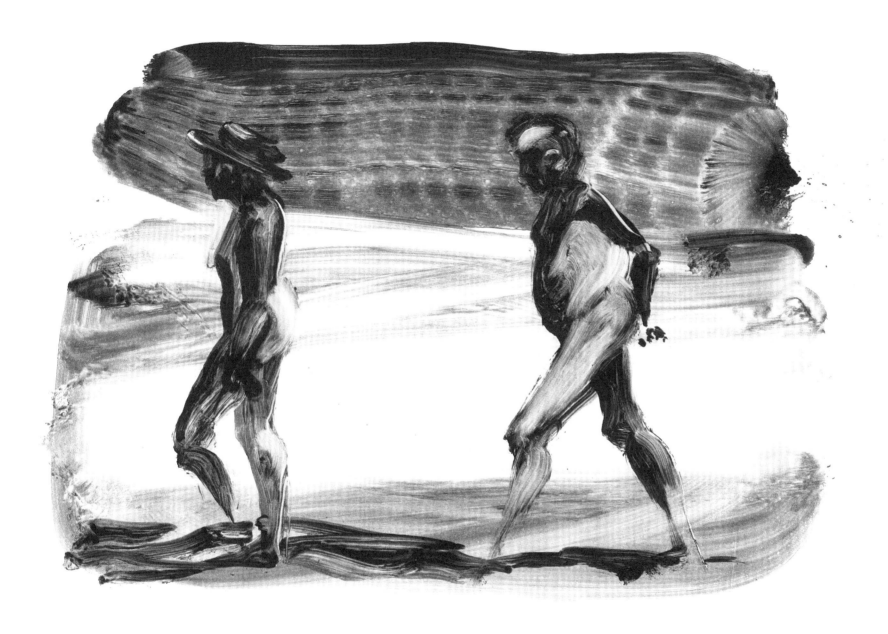

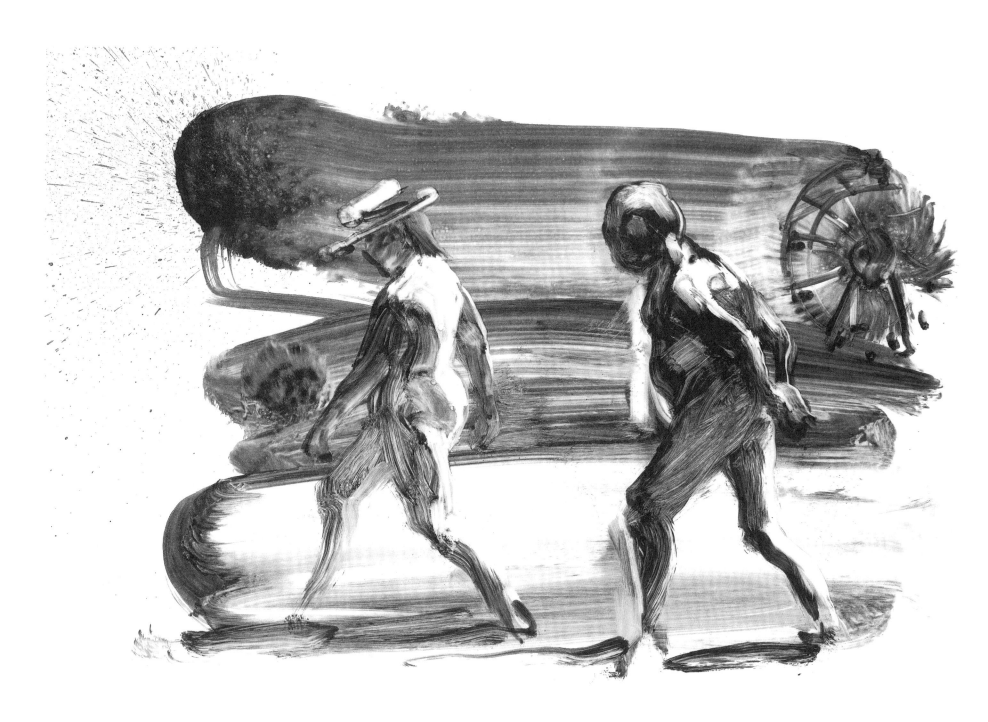

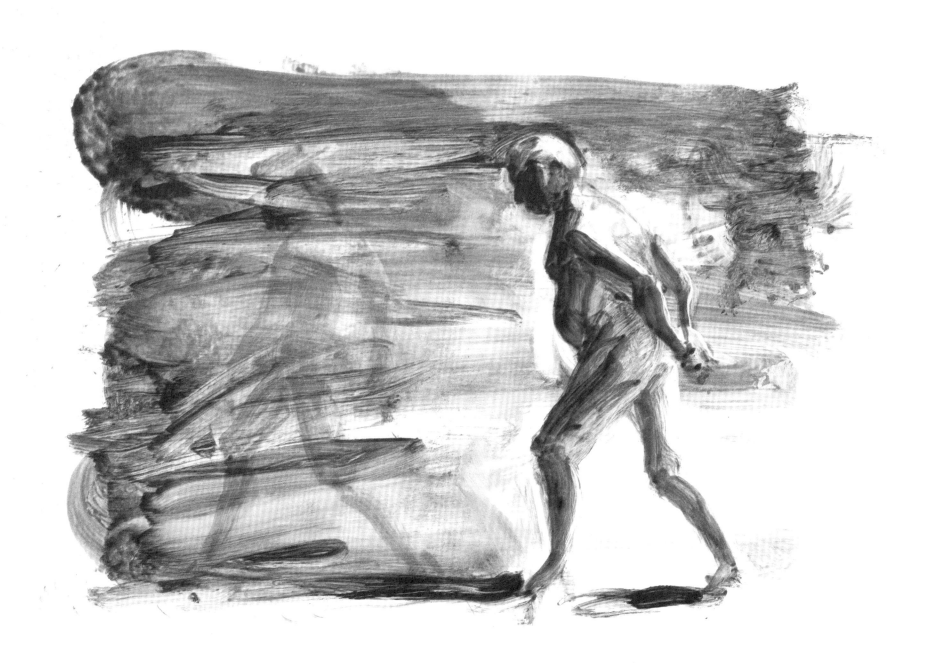

THESE beings
spraddling the dunes
or rumping
in the windows
standing wide legged, day dreamed
or wrapped around chairs,
even the little ones nimbly airborne
over their fears,
they reside.
And whatever we do to them
it is no more than worship,
prayer and penitence,
however we go at them
dressing them
undressing them
holding them
loving them
prying into them
marrying them
they get up and wash their hair.
They're fused to the light
they appear and disappear
as glory darkens
as longing floods us and recedes.
They move as theoplastic royalty
very cruel
like queens with their hand resting
unselfconsciously
on the arm of God
trying to understand our shamed eyes

and bewildered by our abjection
our sullen peasantry of desires
our always present
dogs
nosing up their joints.
They really think
something ought to be done.
You mean you just want to fuck me?
is that all it is?
or will you follow these dark dancing hips
miming to you
what you really mean to say
here on a chair
then gone
here in the suspension of teened nudity
then gone
thighs as gravid as sand dunes
dazzling away in small pools of light?
So I follow her
my hands on my own hips
through this mineraled
sand sea or seawatered sky
I follow her down the infinite beach
her stride
through her thickening times
under that hat
my back bowing
my trunk growing too heavy
for my hairless old legs
I watch the walk of her

I bow behind her
following
following
while the wheels of fire
ferris over the sea
and the sea and the light of day
heave up in sand
the ocean leaping at me like yelping dogs
straining toward me shoulders stiff
forelegs pawing
to fall back as others lunge to reach me.
And she will grind into this elemental universe
the only one
while others towel themselves between the cheeks
and yawn
and I a small doughy boy in the cock of my imagination
stand beside her
and wait
to be told
and wait
to be expressed of all my longing
and wait
for my old gaping heart
to slowly tear open
and empty itself
into the sand.

E.L. DOCTOROW

"A KIND OF ACCOMPLICE IN IT, AN UNWILLING WITNESS TO THE EVENT"

James Cuno

More poem than prose, the untitled text which E.L. Doctorow contributed to *Scenes and Sequences* is a highly crafted and condensed work which, in a few brief lines, directs the reader to the most powerful and troubling themes of the book's monotypes. It was not meant to introduce or, like a coda, conclude and comment on them. Nor was it meant to summarize their many meanings and account for their numerous and varying subjects. Rather, it was one reader's highly articulate response to having looked at them individually and in relation to each other.

In this respect, Doctorow was the book's first reader and it is his narrator who frames our own response to the monotypes. That he does so from the middle of the book is important. For by the time we come across the text, in the space between *Specter* and *Dream*, we have been confronted with a diverse series of scenes which appear to have little in common. *Stroll*, for example, comprises eight monochrome images of a naked older man on a beach pursuing a younger woman who wears only a hat. As she disappears into the fog of the final image, we turn the page to find the first of the seven color prints comprising *Voodoo*, in which half-clothed black men and women gesture wildly and mysteriously, as if conjuring spirits in a mad dance of exorcism. Surprisingly, in the second of these images, a white man leans over or emerges from the body of a white woman lying at the edge of the sea. Are the black figures dancing freely in these prints the exotic other of the more restrained and upright figures of *Stroll*? If so, why are they half-dressed, and what is the relation of dress to physical abandonment?

In *Vision*, which includes just two images, a white woman is seen from behind, caught mid-step in her own exotic dance, as a ghostly figure rises before her. This series gives way to the seven images comprising *Dance*, in which a naked black woman dances before or emerges from a standing white woman who disappears altogether by the third print, leaving the black woman dancing alone before an increasingly turbulent sea and sky. By the fifth print, the black woman has been enveloped by a fog, which recalls that into which the woman of *Stroll* disappeared fourteen images earlier. In the final two images of *Dance*, a fire burns within the fog and the black woman turns to reveal her full nakedness to us.

In *Companion*, a woman, who resembles the dancer of *Dance*, sits on a beach looking into the sun. In the second of the two prints comprising this series, she is accompanied by a black German Shepherd-like dog who lies in the lower left corner of the image where the fire had burned two images before. These figures give way in the first print of the next series to a naked black woman who clearly resembles the earlier dancer and who is later joined by a clothed, red-lipped woman who is then transformed into a naked black youth. In the final two prints of this series, entitled *Specter*, the black woman turns toward us and is changed into a white woman with what seem like large, feathered wings. Her arms are raised as if she is about to ascend and disappear. It is here, after twenty-nine of the fifty-eight images in the book, that we finally find Doctorow's text.

What has happened to this point to prepare us for Doctorow's narrator and his reading of *Scenes and Sequences*? We have seen, as we turned the pages, flipping them like an animation flip-book, figures transformed mysteriously from white to black to white to black to white again, dancing, gesturing, and pursuing each other along the beach at the edge of the sea. Nothing seems fixed in these images. Rather, they are offered to us as a series of suspended moments in a continuously changing non-linear story, which can only be called dream-like in its imagery and structure.

If a dream, then it is certainly a mysterious and exotic one, and one that implicates us in its imagery at just the point of Doctorow's text. For

we pronounce its words, which resound in our head like a chant in simple, insistent rhythms, and are drawn into the narrator's point of view just as we are addressed by the figures in the two prints between which the text falls. These prints, the last of *Specter* and the first of *Dream*, each comprise two naked figures, one looking upon the other. In the first, a white woman is standing in the foreground, facing us with arms raised, while a black youth stands and looks at her from behind. In the second, a white woman reclines in the foreground while another stands behind taking her picture. In each, a naked woman is the subject upon which the person behind gazes. That person, standing opposite us, is our mirrored other, as we look upon the naked woman from this side, as it were. Our gaze completes the framing of the prints' subjects—the naked women on the beach—and this curious symmetry implicates us in their meanings, which turn on the eroticism of looking, of seeing without being seen, of experiencing desire in the private space from which one looks at and reads these images and the text that falls between them. And it is here that we begin to identify for ourselves the book's dominant themes, which cohere, however loosely, around the representation of desire.

As Fischl has said in another context, it is the "self-consciousness about desire that is the mystery of the work . . . what happens in them happens because of desire, which is the mystery I want to paint."[1] Perforce it is a complicated mystery: not simply the conjuring of an idealized object—a man or woman, thing or idea—to satisfy one's desire to make whole what is fragmentary of oneself, but also the recognition in desire of a desperate plea for mastery and wholeness that can never be satisfied. We want of desire an innocent experience. We want to be absent in the presence of the object of our desire. We want to be an unseen witness to an intimate scene of our own making. We want to be at once within and without this scene, to be close to and protected from the object of our desire. And yet, we cannot. We are "a kind of accomplice in it, an unwilling witness to the event," as Fischl has said of his narrative pictures.[2] We are betrayed by our desire, and its object is a figure of lack, a wound, a threat to the fiction of wholeness we wish so much to make of ourselves.

Doctorow's text begins with *Dream* and we are struck by his peculiar choice of words: "these beings spraddling the dunes or rumping in the windows." "Spraddling" means sprawling, simply enough, but it is not a common word. It seems to have been fabricated from "spreading" and "paddling" to suggest the slow, languorous rhythms of lovemaking by the shore. But it is a comic word, too, as it falls flat in pronunciation—like "splat"—forcing the mouth wide in sounding it. In this, in its comic eroticism, it is most fitting as a description of the woman lying on the beach. For she is comical in her awkwardness, in the way her legs spread out and fall to the side immodestly, as if she were unaware or unconcerned with the view she offers others from behind. And yet her awkwardness is erotic in the way her thighs and abdomen press so comfortably against the air mattress upon which she lies, splayed as they are out to either side.

In the second and third prints of *Dream*, a dark-haired, naked woman is "rumping in the windows;" as if rump were the past tense of romp, to play with physical abandon. But there is no abandon here, only a kind of nonchalance as she, like the woman on the beach, is unconcerned with the view she offers others. She lies spraddling the bed, while the clear white light from the window illumines her naked body. Her posture and the setting of the room are reminiscent of so many well-known paintings from the history of art that one suspects Fischl of parodying them. One thinks first of Boucher's *Mademoiselle O'Murphy*, 1751 (Alta Pinakothek, Munich) in which the Irish actress is depicted lying naked across a daybed, her rump luxurious, round, as golden as a peach. And then, by virtue of the light that bathes her body, of Titian's *Danaë*, ca. 1553, (Museo del Prado, Madrid) in which the young goddess lies back and opens herself to receive the golden light of Jupiter's caress. But unlike Mademoiselle O'Murphy or Danaë, Fischl's *Dream* woman neither flaunts her nakedness nor opens herself to fictive coition with the viewer. In this respect she is more like the courtesan of Manet's *Olympia*, 1863, (Musée d'Orsay, Paris), with whom, in the third print, she shares a black cat, the erotic sign of her unseen sex. But unlike Olympia, she does nothing to acknowledge our presence or to arouse our desire. She merely rumps and snubs us, absorbed in her own private fantasy.

Still, we are drawn to her, and to those that follow. We day-dream them, in Doctorow's words, "standing wide legged" or "wrapped around chairs," emerging from and receding into the shadows of our dreams. Even "the little ones nimbly airborne" hold our promises, for like nimbuses, they are radiant in their splendor. We turn to these figures—innocent and exotic alike—to make whole our fragmentary selves through "worship, prayer, and penitence." Yet, we also "go at them / dressing them / undressing them / holding them / loving them / prying into them /

1. Eric Fischl to Donald Kuspit in *Fischl*, New York, Elizabeth Avedon Editions, 1987, p. 39.
2. Eric Fischl to Donald Kuspit in *Fischl* (*supra*, note 1), p. 36.

marrying them," these vessels of hope and specters of fear. What frightens us most is their mute self-absorption. They represent the meaninglessness of desire itself.

In the first print of *Backyard*, a young, naked pre-pubescent girl stands lightly drawn in graphite and graphite wash. She seems to have been conjured by the old, sad-faced woman to the left, who sits up as if called by the idealized vision of her youth. Yet it is a vision that cannot be kept or held in the mind. For in the second print, the young girl has already grown older. Her face is more knowing and her body better defined. She is on the cusp of womanhood, becoming more substantial in form, just as the old woman is growing more faint, drawn more lightly in more transparent washes. By the next print, the old woman has nearly disappeared, quite literally a ghost of her earlier printed form, while the young girl has become even more prominent, drawn with dark washes that disfigure her body and disguise her once delicately drawn features. At the same time, a man has emerged from the shadows to the right. He crouches and strains forward, as if mimicking the dog who, in Doctorow's words, is "our sullen peasantry of desires / our always present / dogs / nosing up their joints."

In the final two prints of this series, the image has been entirely redrawn. The man is now crawling around behind a naked woman as if chasing her, the two of them dog-like in the midst of sexual play. The old woman's dream has lost its innocence; the virginal child has grown darker, is now earth-bound, instinctual and pleasure-seeking, defined by carnal knowledge. And yet, there is irony in the play of these romping, rumping beings. For the man wears glasses, is perhaps myopic, and moves about as if searching for something, as if helping the woman look for a lost earring. Their sexual play is thus rendered mundane, a matter of domestic habit, something more common to the suburban backyard than to the natural garden of uninhibited sexual desire. By the final print, their play has become play-acting and is frozen in time. They are condemned to pointless repetition as their promised carnality is suspended and we are left to rehearse our longing for them.

In *Fable*, a rumpled-bellied woman sits in a chair, naked with legs crossed. As in *Backyard*, this misshapen older woman conjures younger versions of herself: a firm-bodied woman standing wide-legged and another bending over, the two "fused to the light" of our desire. By the strength of their bodies they hold promise of sexual power, but they posture and perform routinely, indifferent to us who, like the seated woman, dream them into being. A dog appears, once again a sign of "our sullen

peasantry of desire," as "glory darkens" and "longing floods us and recedes." Like "theoplastic royalty," these faceless figures are frustrated by our self-consciousness. They think something ought to be done. They call out for motives: "You mean you just want to fuck me?" As if it were that simple. As if we longed only to release ourselves into them, to become them, they who come from us and who condemn "our shamed eyes" for whom they alone exist. They are "teened" in their nudity, these figures: angry, vexed, causing grief or sorrow, their "thighs as gravid as sand dunes."

Beach begins with a lone woman, standing like a sentinel on the far left and staring out across the vast emptiness of the unprinted page. She is full-breasted and thick-hipped, a sister to the women of *Fable*. In the second print, she is joined by two figures: a woman lying on an air mattress and another rubbing suntan lotion onto the buttocks of the first. The marks of the brush, which define their forms by removing pigment from the inked surface of the plate, mimic the movement of the kneeling figure's hands as they rub the flesh of the reclining woman. Everywhere there is the suggestion of intense heat and light and warm sensuality. In the next print, a clothed man enters from the right, shuffling along, his head filled with the sounds of his Walkman radio. He seems headed nowhere in particular, paying no attention to the naked figures before him. In the next print, as he and the lone woman to the left begin to fade from view, two more young women appear, both seen from behind, one naked, the other clothed in a dark swimsuit.

As *Beach* fills up with groups of figures, none acknowledges the others. Another woman appears. Simply drawn and muscular, like a Picasso woman from 1906, she obscures the face of the reclining woman as the clothed man recedes farther from view. In the next print, the lone woman on the left is redrawn, the two central figures disappear, and a young androgynous figure kneels center stage and looks up as if startled by a sound. In the final print, the man on the right is transformed into a woman who bends forward, straining to hold back a young dog, the only sign of life in this otherwise quite troubling and static scene. Nothing much happens in these images: figures come and go and are transformed; they are silent and, for the most part, inanimate. Only the androgynous figure shows its face to us; and then its face stares blankly, suspended in its recognition of something outside itself, giving little of itself to we who gaze upon it. What are we to make of this narrative, which is constructed discretely by the addition and subtraction of figures naked and clothed? One is reminded of Doctorow's words: "fused to the light / they appear

and disappear / as glory darkens / as longing floods us and recedes." We long for these figures, and yet they offer us nothing. They remain mute in their self-absorption: "they get up and wash their hair . . . dazzling away in small pools of light."

At this point in Doctorow's text, with but one monotype series remaining, there is a shift in narrative voice from the first person plural to the first person singular. The distance from which we had generalized upon the experience of desire is taken from us and we are made to identify with the narrator's personal confession as we pronounce with him the nominative pronoun: "So I follow her," "I follow her down the infinite beach," "I watch the walk of her / I bow behind her." I am no longer absent in the presence of my desire. I am an accomplice in it, an unwilling witness to the event which is the drama of my unmaking. And I return to the start of *Scenes and Sequences* and the five monochromatic monotypes with which it begins.

An old man, naked, hands on hips, pursues a woman dressed only in a broad-brimmed hat. She seems at first unaware of his approach, but then lengthens her stride, matching his step for step. His pursuit is purposeful. He looks up and opens his mouth as if to call out, but she moves on, ignoring his presence, now just a few steps away. In the third print, a spinning form appears in the far right background, driving the inky sweep of the brush in waves from right to left. In the next print, it becomes a ferris wheel, spinning faster and faster, keeping pace with the man's increasingly desperate gait, until the background brushwork explodes over their head and the woman disappears into the fog. The man is left alone. His hands are clasped behind his back, his belly forward, his head down; his pursuit futile, profitless, dream-like, teased by the full, swinging hips of the curvaceous woman as she strolls through the space of the "mineraled / sand sea or seaward sky."

We grow older, she and I — "her thickening times / my back bowing / my trunk growing too heavy / for my hairless old legs" — and still longing floods within me as the "wheels of fire ferris over the sea" and the light heaves up in the sand and the ocean leaps at me "like yelping dogs / strain-ing toward me shoulders stiff / forelegs pawing." And I am afraid. I am afraid of the "dark dancing hips" of the woman I pursue. They will "grind into this elemental universe" me, who in the flush of my imagination am but "a small doughy boy," ill-formed and fleshy in the desperate fiction of an old-man's vision of himself. Nevertheless, I

> stand beside her
> and wait
> to be told
> and wait to be expressed of all my longing
> and wait
> for my old gaping heart
> to slowly tear open
> and empty itself
> into the sand

And I am alone, spent, and left to ponder the pain of my desire. For I have come to the end of Doctorow's text and find myself at the beginning of the book and, in the words of Wallace Stevens, have lost the whole in which I was contained and know "desire without an object of desire / All mind and violence and nothing felt . . . Like the wind that lashes everything at once."[3]

This is the subject of Eric Fischl's art: the ancient cycle of which Coleridge wrote, "The still rising Desire still baffling the bitter Experience, the bitter / Experience still following the gratified Desire."[4] And it is the great beauty of *Scenes and Sequences* that it offers a profound meditation on the desperate plea for mastery and wholeness that desire itself can never satisfy.

3. Wallace Stevens, *The Palm at the End of the Mind: Selected Poems and a Play*, ed. Holly Stevens, New York, Vintage Books, 1972, p. 278.

4. Samuel Taylor Coleridge, *Notebooks*, ed. Kathleen Coburn, New York, Pantheon Books for Bollingen Foundation, Bollingen Series L, 1957, quoted in Helen Vendler, *Wallace Stevens: Words Chosen Out of Desire*, Cambridge, Massachusetts, Harvard University Press, 1986, p. 43.

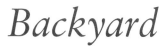

Backyard

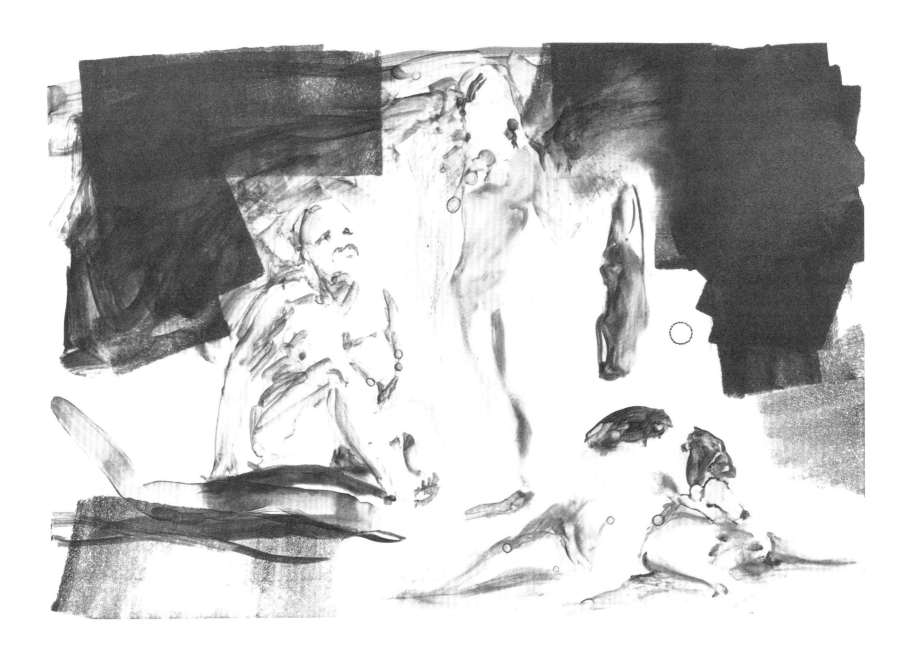

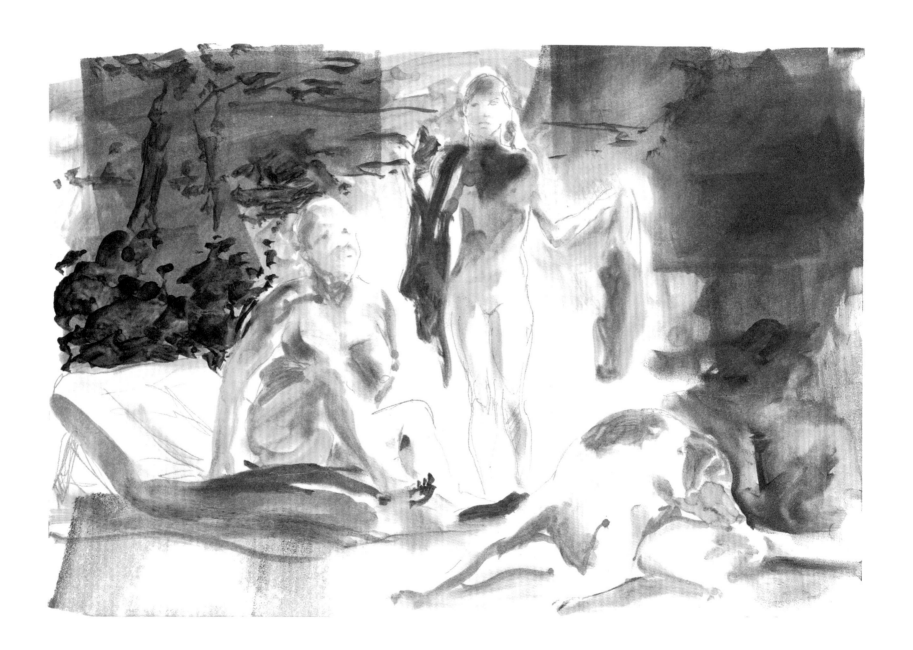

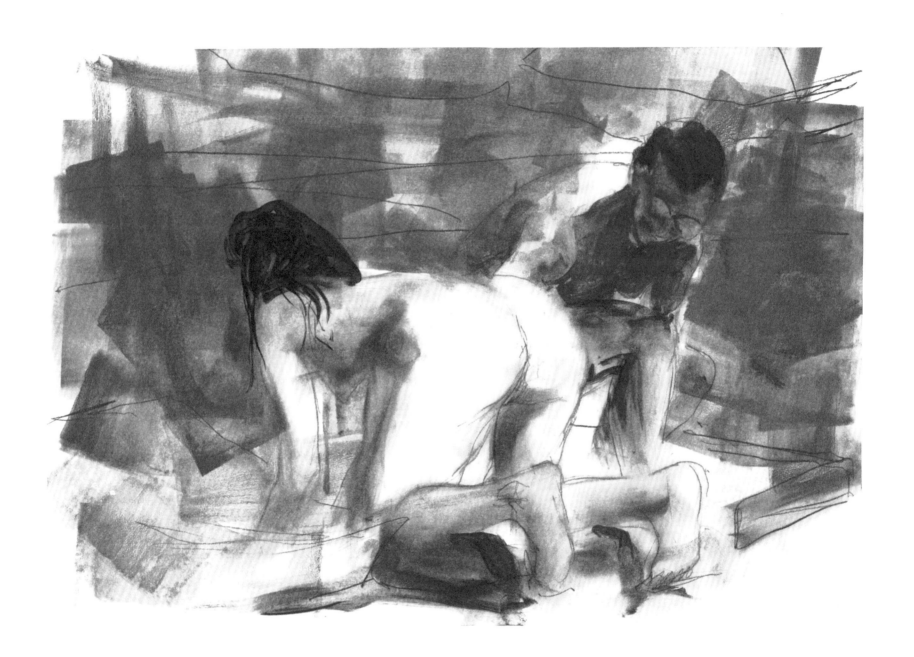

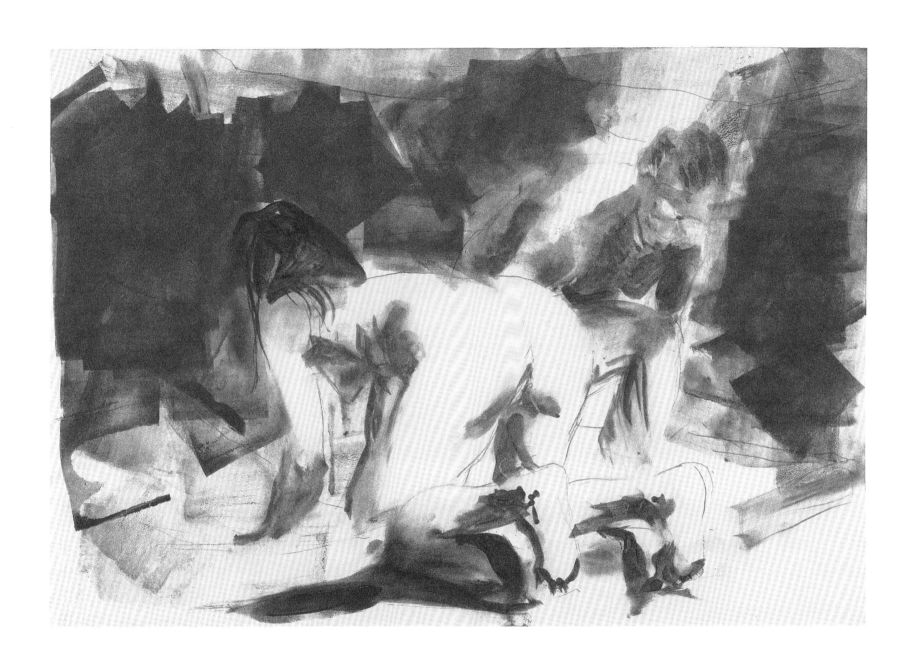

THE DREAMS AND LIES OF ERIC FISCHL'S MONOTYPES

Richard S. Field

Eric Fischl has developed a number of discrete processes to further the production of meaning. But the fact that one can never quite specify "whose meaning?" is central to these various strategies, each of which carefully reveals and then obscures the artist's intentions. Fischl's well-known willingness to comment on his own works and to reveal the sources of his imagery rarely illumines the emotional transactions among his figures. In this he is profoundly indebted to nineteenth-century Symbolism. While the viewer may feel familiar with Fischl's subjects and obsessions, it is his or her fantasies that are forcibly engaged. The more one constructs Fischl as object, the more one constructs oneself as subject. A similar experience attends the interviewer who has been showered with revealing responses, empathetic sympathy and disarming frankness. The natural grace of Fischl's generosity and the handsome openness of the artist's demeanor are not unlike the beautiful surfaces of his paintings. Nothing seems prior—the exterior skin does not obscure past decisions and changes. Just as there are few pictorial ambiguities to distract the viewer from the ostensible subject, so there is no verbal sparring to cloud the visitor's notion of the artist's intentions. Nonetheless, one has to accept the ultimate irony that in Fischl's art the more that is known, the more remains indeterminate.

Those who have written about Fischl have been fascinated by the themes of his work and their relevance to contemporary American society. Less often have his commentators attempted to describe, and even less to interpret, single paintings. Given the artist's own revelations, the apparent familiarity of his subjects, and the implied narrative structures of the works, how could any engaged viewer not be drawn into reading these dramas? With the passage of the 1980s, it has become increasingly obvious that the contents of these works are encoded in languages and visual sequences that evade verbal description. It is not simply that the works might be understood variously by different viewers, but that most interpretations remain inadequate. Increasingly, Fischl's meanings are grounded in the languages of human bodies—by their sex, race, age, costume, pose and gesture (but almost never facial expression); in the nature of the spaces that enclose and separate them from each other; in the pigments that describe, surround and invade them; and in the rush of historical and psychological associations imbedded in each of them. Yet, these figures rarely operate as emblems or metaphors: they are simply triggers for deep but intangible and decidedly non-literary associations. It is never the identity of Fischl's sources, for example, that enables one to decode a specific meaning (although one always desires the consolation of that knowledge), but rather their evocations of another cultural context, a timeless past, a primordial psyche, or even of the irretrievable promises of our own myths. It is the aura and the syntax of human figures caught in moments of unguarded and incipient bodily expression that contribute to those elusive and unconfirmable meanings we know to exist in our own memories.

I do not wish to imply that the mechanisms of meaning are the exclusive focus of Fischl's works, but rather that they have entered into a very subtle dialogue with and on occasion have displaced our ordinary expectations of narrative pictures. This very dialogue emerges most cogently in the hints we have had of how the paintings actually develop. Significantly,

Richard S. Field is Curator of Prints, Drawings and Photographs at the Yale University Art Gallery.

I am deeply grateful for the encouragement and help I have received from several persons. First among these is the artist himself; I hope I have not stretched or distorted our conversations beyond recognition. My friend, Miklos Pogany, has been wonderfully sharing of his ideas about Fischl's work, from which I have drawn considerably. Thanks are also due Andrea Scott and Peter Blum for their cheerful participation. But it is to my wife, Lesley K. Baier, that I owe the most abiding appreciation; she has repeatedly improved this essay with her trenchant criticisms and precise proofing.

the most crucial element is Fischl's innate understanding that the processes by which he arrives at any given image are as foreign and as strange to him as are the ultimate meanings of the works.[1] Thus, the sense of removal experienced by the artist in the act of making has permitted Fischl to reveal so ingenuously what little he knows. Eventually one gathers that a good deal of the artist's commentary could either be rehearsed or—its opposite—invented.[2] Both are true. By suspending narrative closure, and thereby suspending the viewer, at some remove from what appears as all too familiar, Fischl gently deflects attention from the artist's supposed intentions to those of the viewer. Clearly there are no choices right or wrong, only the uncertainty of meaning aided and abetted by the assertive presence of the painted surfaces themselves.[3]

If the critical literature has been fascinated with Fischl's blatant Americanness and his deconstruction of the American myth of happy suburban existence, how has he inscribed himself and his practice in the work? Can we detect personal values imbedded in his fascination with the untoward acts, taboos, desires, hostilities and indeterminate events of his paintings? Are they contained solely in Fischl's stated ideas about the failure of American culture to deal seriously with sexuality, desire, parenting, hostility and death—that we are a citizenry that acquires, plays, distracts and makes material demands upon life but cannot pause to contemplate the tragedies of the human condition itself? Or do these meanings serve a deeper anxiety that is ironically inscribed onto Fischl's very surfaces?

Fischl's surfaces are changeable, uneven, overpainted, and transparent all at once. They are rich applications of fluid media, attracting the eye by promised sensuosities, and seducing the viewer by optical and material splendor—much as the look of the suburbs (and our image of them) promises a haven of resolution. The agility, mastery and palpability of Fischl's brush and washes, the unexpected lush hues, and the devices that incorporate the viewer in the space of the work and involve him or her in the dramas promise more security and safety than careful reflection can verify. The images are designed for the "quick take," for an incautious involvement with a surface that tricks and betrays the spectator and eventually forces a reconsideration of his or her conclusions.[4]

Ultimately it is the total fluidity of *both* surface and meaning, as well as the instability of the identities of his characters, that determines Fischl's perpetual lack of resolution. This lack of certainty is expressed by the unrelenting desire so many have detected in Fischl's work, a desire that encodes loss and longing. And with his own loss the artist manages to defeat the viewer's sense of identity. It is the purpose of this paper to explore how the artist has allowed himself to partake of the process of uncertainty. In the end, the seeming accessibility of the artist and the seductiveness of his surfaces (and his images) mimic the superficiality of the very society they wish to critique. Similarly, the spaces articulated by Fischl's characters inevitably are fraught with ambiguity: do they suggest aggressive distancing or are they charged with the magnetism of desire (loss)? The viewer is caught in the web of forces spanning the actors, a mesh that brings his own feelings, like those of the painter, to a dead stop. Here is the core of Fischl's potency, his uncanny ability to raise our resistance to taking sides, rendering impotent our desire and compassion.[5] Why such an undermining of the viewer's identity should be so moving or so apt for a contemporary audience raises disturbing questions. Has he intuited a particularly striking contemporary pose of which we are unaware? What seems so "just" about Fischl's work, therefore, may be its capacity to construct meanings toward which we are invariably drawn but with which we come to terms only in a murky, threatened and unresolved fashion.

* * *

Although Fischl experimented with monotypes in 1985 while working on the color aquatints of *Floating Islands* at Peter Kneubühler's in Zurich, it was a year later that he began to explore the medium in earnest. On the

1. Such an attitude of nurturing the unexpected in the work-in-progress jumps out from the pages of the "sketchbook" edited by Fischl and Jerry Saltz, *Sketchbook with Voices*, New York, Alfred van der Marck Editions, 1986.

2. "When I am asked to explain my work, I end up telling another story, adding another layer of fiction." Eric Fischl to Constance Lewallen, 1988, in *View* 5 (Fall 1988), p. 22.

3. One thinks of the entirely different strategies adopted by Jasper Johns to shield his intentionality. I am reminded, for example, of the hard-won successes at decoding the systems of the complex hatchings of *Untitled, 1972* (Ludwig Museum, Cologne). In the final analysis, little more was revealed of Johns' meaning than the elaborate metaphorical interpretations attempted by other critics. However, Johns has allowed new work to accrue and subsume meanings that have been attached to previous endeavors. This was particularly true of the hatched paintings after 1972.

4. "I want people to feel they're present at a scene they shouldn't be at, and don't want to be at." "The scene has to be taken in very fast and left as quickly, and then slowly digested." ". . . they're a kind of accomplice in it, an unwilling witness to the event." Eric Fischl to Donald Kuspit in *Fischl*, New York, Elizabeth Avedon Editions, 1987, p. 36.

5. "In America you learn that the space between people is potent, an aggressive space. . . . In my recent paintings, the people are staring back, creating a direct and disarming relationship with the viewer." Eric Fischl to Tazmi Shinoda, 1988, in *View* 5 (*supra*, note 2), p. 9. Or, on Edward Hopper: "The paintings are steeped with the conflicts of puritanism: the self-consciousness of watching with desire." p. 19.

first of March 1986, Fischl set to work with printer Maurice Sanchez in New York. During the remaining months of that year, Fischl returned to Sanchez's workshop at least a dozen times, completing the thirteen series reproduced in *Scenes and Sequences*, as well as six others.

The monotype is a transfer of ink, paint, or pigment in some other liquid vehicle from one surface to another. Unlike the classical forms of printmaking (including woodcut, engraving, etching and lithography), the surface on which the artist works is never altered. There are no lines or tonal granulations cut into, etched, or chemically imposed upon that surface; it is nothing more than a carrier of an image drawn by the artist. Since the major portion of the pigment is transferred during printing (usually onto paper), the traditional monotype yielded but one impression; hence its name. Unfair though it may be, it is convenient to think of the monotype as a hybrid, a printed drawing that possesses its own easily recognized characteristics. The dark-field monotypes, for the most part executed by removing pigment from a thoroughly inked surface, are uncannily luminous; their lights glow through the brushstrokes and other marks made by the artist. The lighter monotypes, created more from the deposit of pigment than from its removal, are like compressed drawings. It is the act of compression during printing, as a matter of fact, that may yield the most unexpected and unusual results. The image is subtly wed to the paper though still endowed with the immediate presence of an original drawing. This merging often produces marvelously extended scales of tone, color and texture—captivating in their own right but rich as well in spatial subtleties.

Toward the end of the nineteenth century, artists like Edgar Degas and Paul Gauguin began using the monotype as a means to explore their figures and forms; they were also intrigued by the lighter, even ghostly images yielded from second and third pulls. Invariably, these were reworked in other media, radically altering the color, space, and even psychology of each successive print. Yet, few if any of Fischl's predecessors, with the exception of Richard Diebenkorn, exploited the monotype's potential for seriality.[6] For while the tones might become less saturated with successive pulls, there remains the distinct possibility of going back to the plate and making further additions and subtractions. A given image can therefore be altered; it can be strengthened, shaped, or radically reworked—all the while preserving crucial vestiges of its former identity(ies). Because remaining unfamiliar with the final shape of his pseudo-narratives is so essential to Fischl's method of composition, the monotype provided an unexpectedly sympathetic new means for carrying out his work. Indeed, his explorations of the serial potential of the monotype, though not the first, were nonetheless brilliantly innovative.

Fischl's first monotypes shared little with those of their most famous forebears: Benedetto Castiglione, Camille Pissarro, Frank Duveneck, William M. Chase, Degas and Gauguin. Rather, and surely coincidentally, they descended from the broadly handled, coloristic monotypes of his American forebears, Maurice Prendergast, Arthur B. Davies, John Sloan and Milton Avery. According to Sanchez, neither he nor Fischl harbored many preconceived ideas about the monotype when they began to work on this project; what emerged basically reflected the artist's own oil sketches on paper. But Fischl's habits of composition and his rapt attention to the sensuous surface quickly determined the most salient features of the new monotypes.

Above all else, Fischl's work had been known for its collage-like procedures, which began with the glassine drawings of the late 1970s. These overlays of separate, translucent figures facilitated composition by improvisation, a method not unlike that of Gauguin who returned time and again to a repertoire of figures similarly derived from a combination of sketches (observation), photographs and a vast range of painted and sculpted sources. During the 1980s, the lessons of the glassine drawings were gradually absorbed into the paintings, in which the artist would find his characteristically charged subject matter. Fischl's descriptions of how his subjects emerged—almost of their own volition—themselves have a long pedigree, dating back at least to Edgar Allen Poe's *Philosophy of Composition* of 1846.[7] Fischl's remarks about how subject and meaning

6. Although Degas and Gauguin often pulled successive impressions of the same image, they seemed to avoid reworking that image so as to develop or change its significance. Nevertheless, both artists did utilize tracings and transfers for further elaboration. The true serial qualities of the monotype, however, have occasionally been exploited by such contemporaries as Michael Mazur, Nathan Oliveira, and especially Richard Diebenkorn. See Colta Ives, *et al.*, *The Painterly Print: Monotypes from the Seventeenth to the Twentieth Century*, exhibition catalogue, The Metropolitan Museum of Art, New York, 1980.

7. See Eric Fischl, "Figures and Fiction," *Aperture* (Winter 1985), pp. 56–9; Eric Fischl, "How I make a painting; picturing it . . . ," *New Observations: Art and Culture* 3 (October 5, 1981), n.p. (typescript). It is not at all by chance that a Symbolist such as Gauguin also alluded to Poe's *Genesis* in his own explanation of *Manao Tupapau* of 1892. See Paul Gauguin, *Cahier pour Aline*, facsimile edition, edited by Suzanne Damiron, Paris, Société des amis de la Bibliothèque d'art et d'archéologie de l'Université de Paris, 1963. For Poe's text, see Edgar Allen Poe, *The Raven and Other Works*, Boston, Northeastern University Press, 1986.

seem to unfold during the process of painting disclose the same fascination with a sense of the inevitable. What is not revealed, however, is how often the artist has rehearsed his motifs in the form of drawings in which many figures are worked up from his stock of photographs and reproductions. As much as we have delighted in naming Fischl's pictorial sources, there really are no beginnings. Once the techniques and kinds of source materials to be employed had been established, the artistic process was as much making as inventing, one that allowed continuous self-discovery through exploitation of the methods of finding.[8] It is this construction of meaning that Fischl has so keenly honed, which is not unlike the approaches used by his contemporaries, David Salle and Francesco Clemente.

There are many ways that Fischl's processes are indebted to those initiated by Robert Rauschenberg twenty years earlier. Both artists proceed by the collage method, raking in the leftovers of any given moment, while generously mining the past for its images and symbols.[9] But where the older Pop artist is mainly concerned with the meanings of media and the impact of its images on modern life, suggesting very general categories of stylistic and metaphoric interpretation, Fischl devotes himself to far more restricted areas of meaning: the awakening of sexuality, the conflicts arising from desire, the collision of cultures, *etc*. All of these seem concerned with the psychological rather than the formal conditions of modern culture. In like fashion, the two artists' methods of composition betray both similarities and fundamental differences. Rauschenberg invariably set himself the task of finding coherence in materials that lay at hand and, in the 1960s at least, constructed his tableaux so that the graphic codes of his sources (*e.g.*, reproductions of sporting events from a day's newspapers) were a critical aspect of his content. On the other hand, Fischl, who also might commence with a limited repertoire of images (*e.g.*, his own photographs from the beaches of the French Riviera), is concerned with codes of posture and behavior and their implications for human interaction and social discourse. And while both artists manifest similar feelings for the interweaving of the painted stroke and the depicted object,

Rauschenberg tends to oppose handmade and reproduced images, while Fischl prefers to elide the languages of paint and figure.

Both Rauschenberg and Fischl share a deep conviction that meanings are as much the responsibility of the viewer as of the artist. Rauschenberg's media plots are no more readable than Fischl's narratives are resolved. But Fischl raised the ante in a new way: figures are allowed to appear and disappear (they are altered if not totally overpainted) during the process of work; meanings alter themselves by suggesting new motifs. And these changes are always those that affect the body's language, the character's thought, the painting's narrative and, of course, the viewer's interpretations and intuitions. After the glassine drawings (fig. 1, p. 55), Fischl evolved new ways of changing the story line that permit the spectator an extraordinarily free role in structuring the narrative (a notion that has its roots in age-old picture games). For example, the six color etchings that comprise *Year of the Drowned Dog*, 1983 (fig. 3, p. 57) may be rearranged, almost at will. And two years later, in the oil painting *Saigon Minnesota*, 1985 (fig. 4, p. 58), Fischl began to disperse his narratives over several panels. The color etchings of 1985, *Floating Islands*, were also constructed to suggest a fluid kind of relationship among its five parts. With the inception of the monotype project in 1986, Fischl could add a further variation: the capacity to make a permanent record of what had previously been ephemeral: the gradual metamorphosis of his imagery.

* * *

It would be misleading to claim that Fischl turned to the monotype solely because of its serial potential, although he was very quick to discover it. The first series, *Stroll*, included five monotypes, of which the first three were physically unconnected.[10] Each was separately drawn with brush and lithographic inks on mylar film (a material used infrequently for the monotype).[11] Highlights were wiped out with rags, the stick-end of the brush and, less frequently, the fingers. The first image—a man apparently following a woman who holds her left hand to her groin—could not have been more directly crafted. Curiously, the subsequent monotype increases the distance between the two figures; the woman becomes more lithe, the

8. I am profoundly indebted to the several essays of Richard Shiff on this subject, including "Making a Find: An Argument for Creativity, Not Originality," *Structuralist Review* 2 (Spring 1984), pp. 59–80, and "Representation, Copying, and the Technique of Originality," *New Literary History* 15 (Winter 1984), pp. 333–63.

9. "Fragments are decontextualized and are reassembled. That is the essential Modernist technique." "What perspective did for seeing, collage does for thinking. It's how we think." Eric Fischl to Tazmi Shinoda, 1988, in *View* 5 (*supra*, note 2), p. 11.

10. While five impressions of *Stroll* appear in *Scenes and Sequences* and the present exhibition, in point of fact ten exist. In general, some of the unreproduced monotypes are simply second impressions of a given state, while others record a separate working stage.

11. I would like to thank Maurice Sanchez for the many technical insights he provided during a visit on April 27, 1989.

man paunchier. In the third narrative frame, the woman becomes darker, and a phallic cloud appears above.[12] What began as a casual stroll has become a more serious pursuit. But the artist has not yet reached his meaning, and in the fourth frame the scene is once more transformed. As the man doggedly gains on his quarry, the woman becomes less a fantasy of youth, and the game they play becomes shadowed by the cruelty of age. In the fifth frame Fischl discovered that rather than fully obliterate his image, he could simply alter the existing marks. The ferris wheel (reminiscent here of Duchamp's chocolate grinder) and its phallic cloud begin to fade even as the woman becomes little more than a shadow; but the man forges on, undeterred, the automaton of desire.[13]

How appropriate that Fischl should have commenced this series with such simple directness, and little wonder that E. L. Doctorow unerringly focused on Fischl's obsessional encounters with desire and middle-age loss. But as in Jasper Johns' *Device* imagery, it is the desire of the observer that both generates the meaning and unconsciously mirrors the depicted loss. The disappearance of the object (the woman) and the eventual fading of the subject (the man) underscores the rootedness of desire in absence and loss. In discovering the alterability of the monotype—that some elements might remain totally unchanged while others were altered and lost—had not the artist also uncovered the source of his own pictorial compulsions, the meaning of his art? Not just desire and its consequences, but desire as compensation for absence and loss.

Ten days later, Fischl returned to the printer to work on a new series of monotypes, again drawing upon visual materials he had brought with him: his own beach photographs and a group of illustrations from Gert Chesi's book on African voodoo.[14] The monotypes of *Voodoo* made a determined leap from the tentatively brushed, monochromatic grays of *Stroll*. After a false start with rather haphazardly applied pigments,[15] the artist impetuously shifted to a boldly conceived structure and color. The background was evoked by rapid, back-and-forth movements of the brush out of which the main figures were coaxed by wiping and further drawing.

Without doubt this is the most enigmatic of the series; at no point can one assign reasonable meanings to the depicted actions. Fischl has avoided the narrative sequences of Chesi's book while drawing freely from its images of women possessed by the voodoo gods.[16] The frenzy of two black women leads to the demise of a third whose spirit seems to arise spontaneously from her prone body. Suddenly one of the legs of the prone figure becomes that of a new dancer, while she herself assumes a curled up position and changes from white to magenta. The swirls of paint become increasingly loose, the figures more off-balance, the story more impenetrable. In the next frame, the left-hand figures remain unchanged spectators while the curled figure lifts both hands and rises (as if possessed). If anything, the wipings and scrapings have become even more frenetic. In the last frame, which bears no vestiges of the preceding, a ghostly, light (white?) figure stands over the completely vanquished, prostrate figure of a single black woman.

In none of the remaining monotypes will Fischl display such unrestrained, libidinal excesses. Perhaps the final frame of *Voodoo*, with its ghostly, but constrained white figure, does indeed evoke white dominion over unbridled, black forces. Old-fashioned racism is *not* quite the issue, however. Fischl's frequent oppositions of black and white are far more intended to pry into the viewer's cultural and psychological predispositions. The outlandish gestures of black voodoo might be regarded as standing against the subtle (and often hostile) meanings of white body language.[17] Inevitably, the black acts as a critique of the white, just as the frenzied applications of color and wiping summon up an energy that differs sharply from the more traditional techniques of the subsequent *Man* and *Fable* monotypes. Only in *Voodoo* did Fischl find as complete an interpenetration of technique and narrative as had enthralled the paintings of 1986–88, where the thin washes would constantly overlap, penetrate, and

12. The rotary shape at the right, which was to become a ferris wheel, was formed quite accidentally by the splaying of the brush as it was lifted from the mylar sheet.

13. In the last [unpublished] monotype of this series the man dematerializes and the woman vanishes almost completely.

14. Gert Chesi, *Voodoo, Africa's Secret Power*, Cape Town, C. Struik Publishers, 1980.

15. The first couple of pulls employed an aluminum plate, which grayed the colors and was soon replaced by mylar.

16. The borrowings might be recorded in tabular form to make this point clear; see the reproductions of these monotypes in the catalogue section of this book, nos. 6–12: no. 6—both figures from p. 153, top; nos. 7 & 8—both figures inspired by those on pp. 76–7 and 124–5, though the right hand woman clearly was drawn from the photograph on p. 166, lower right; no. 9—tumbling (?) figure from p. 196, lower right; no. 10—kneeling figure from p. 190, lower right; the figure directly behind her from p. 190, upper left; middle figure from p. 198, upper left; no. 11—kneeling figure from p. 190, lower left; no. 12—both standing and prone figures from p. 190, upper right. The sequence on pages 189–92 depicts a voodoo lawcourt in which an accused woman's guilt is assessed by her ability to dislodge a buried palm nut. Clearly Fischl "borrowed" the unusual physical gestures while detaching them from their specific narrative context.

17. Discussion with the artist, May 4, 1989.

even constitute Fischl's actors. By interpenetration I mean more than a transparency of foreground to background, but a total equivalence of figure to ground. Such a reciprocity of form and figure, very much a part of the language of the monotype, is integral to Fischl's fixation on the materialization and disappearance of his players. In an uncanny fashion, it also reflects something of the physical and cerebral extremes of *Voodoo* itself.

Vision, which comprises only two plates, was executed a few days after Fischl completed the black imagery of *Voodoo*, and was surely intended as a conscious counterpart to it. Ironically and purposefully, the figure in this series was derived from a photograph of a wildly dancing white woman snapped by the artist at a beach party. In the second frame her flesh acquires pigment and she is joined by an apparition of a deathly partner (recollections of the late-medieval Dance of Death).[18] There is neither setting nor story, but one senses an abrupt shift in the psychological construct of the scene. Whereas in the first frame we are voyeuristic witnesses to a self-absorbed performance, in the second the performer herself is abruptly confronted. Our interpretations change along with her thoughts (Fischl speaks repeatedly of the thoughts of his characters), and the spectator has become a more distant observer.[19] In these monotypes, the viewer's ground is repeatedly shifted, forcing an awareness of the very slippery nature of our own construction as subjects.

Time and again in Fischl's monotypes one is witness to metamorphoses of race, gender, age and class (not to mention the addition and subtraction of entire figures). These sea changes are the qualities that most affect the constitution of the viewer's own thought, if not identity. Not unlike the spatial dislocations of those artists who challenged the relatively fixed meanings of Renaissance space and rationality, the constant changes of identity in Fischl's work play fast and loose with the "viewer in the picture." Even though only three of the twelve monotypes of *Dream*[20] are published in *Scenes and Sequences*, they nonetheless encompass the drastic move from public to private space, which substantially mutates the viewer

from curious spectator to desirous intruder. At first, someone else does the "looking" (making a photograph, in this instance), but suddenly it is the viewer who does the "taking." Located in a closed room, the outdoors glimpsed only through the windows, we are now alone with this sensuously reclining woman who has moved, unaltered, from beach to bed.[21] In the final frame, radical change gives way to subtle alteration: as the room gathers specificity, the viewer feels a greater intimacy.

During the four weeks that intervened between *Dream* and the next series, *Man*, Fischl must have investigated the history of the monotype. Clearly, his attention was drawn to Degas' night-world monotypes. The luminous sensuosity of Degas' technique must have struck Fischl as the perfect vehicle for the older artist's repressed but intense interest in the female body.[22] In *Man*, Fischl temporarily abandoned the color and sunlight of *Voodoo*, and adopted Degas' atmospheric blacks. Borrowing a figure from Thomas Eakins' well-known photograph of Pennsylvania Academy students bathing, and exploiting the more granular, aquatint-like surface of inked linoleum, Fischl created a dark and moody interior study, with the nude seated on a table rather than among the rocks of Eakins' swimming hole.[23] Virtually all of the drawing was achieved by removing the black ink with a cloth or the tip of the brush. The man gleams in the dark, and uncannily preserves Eakins' late-nineteenth-century, uneasy awkwardness. He is indeed a figure with the aura of another time, another morality and another psyche. After several intervening impressions had removed much of the ink,[24] and slight reworkings had altered the upper body and added a window, this languid and contemplative figure re-

18. The same unexplained, Salome-like figure appeared in the oil painting *Manhattoes*, 1985 (Private Collection).

19. "That fifth panel then completely transforms the other four panels. . . . [It] locks the narrative into a specific event." "It is the moment when thoughts change." Eric Fischl to Constance Glenn in "Conversation with the Artist," in Constance Glenn and Lucinda Barnes, *Eric Fischl: Scenes before the Eye*, exhibition catalogue, University Art Museum, California State University, Long Beach, California, 1986, pp. 12 and 13.

20. The reader is again reminded that not every monotype represents a revision; from time to time Fischl would pull one or two impressions without touching the plate at all.

21. The first impressions of *Dream* reveal how very much this series metamorphosed. Originally, two seated women in brown washes were accompanied by a third who slowly crouches and then stands at the right. The two were then replaced by the reclining woman of the final scenes. Two frames later she is being photographed by the standing woman, who, in the next frame, disappears altogether.

22. "He's voyeuristic. He's much more involved with psychology and sexuality than Manet. Manet is someone I'm working against. . . . So I work within the realist tradition of meaning. . . . I work in the tradition of the moralism of Daumier." Quote in Nancy Grimes, "Eric Fischl's Naked Truths," *ArtNews* 85 (September 1986), p. 77.

23. The photograph was used by Eakins for his painting, *The Swimming Hole*, 1883 (Amon Carter Museum, Fort Worth). See Constance Sullivan, ed., *Nude Photographs 1850–1980*, New York, Harper & Row, 1980, plate 28. Fischl has mined the book for several other figures, as will soon become evident.

24. One immediately thinks of the effects of burnishing the granulated surface of a traditional copperplate aquatint. The comparison is apt because the ink printed from the linoleum blocks has a rather coarse grain that reminds one very much of aquatint. I am thinking, particularly, of Jasper Johns' process of burnishing and thus lightening the many-

mained much the same, permeated by an air of subtle conflict, an internal struggle between those very forces of light and dark that articulate the monotype itself. As in *Dream*, the artist's moment of insight occurred only after the completion of considerable work and culminated in the emergence of a new figure—a powerful female form, possibly black. So unmistakably opposed to the man is she in her aggressive stance and her muscular physique, and yet so clearly does she appear to spring, like Eve from Adam's rib, from the Eakins figure, that one cannot help but fantasize an alter-ego, a shadow figure, a dominant other. And like the woman in *Stroll*, she touches her own genitals, while holding her left arm aloft as if in triumph.[25] The solitary, brooding figure, sensitive to his own fragility, is aroused by the dark side of his imagination. Is she a phantom or is she real? Is her potent (masculine?) sexuality the verso of his timidity, or does she represent a fantasy of arousal that urges the viewer to look again at the half-tumescent penis of the seated man? And what changes in thought and emotion are evoked by the removal of the shadows that shrouded the man's head and torso in the previous impressions?[26]

Man directly confronts the issues of the nude and of Fischl's supposed sexism. The appeal of the Eakins nude, I think, lies in its passivity, while the female seems so actively masculine. These role reversals not only continue to obsess Fischl, but seriously weaken any attempts to portray him as the perpetuator of the patriarchal hegemony. The precise appeal of the Eakins model is his inviting languidness, his "to-be-looked-at-ness" and his subtly feminine nature, all of which must correspond to aspects of the artist's own psyche and probably account for much of his own beguiling openness. The series further emphasizes how minor are the differences in

Fischl's presentation of male and female figures, but still leaves open the question of the construction of the viewer: male, female, both, neither? *Dream* and *Man* raise important issues about desire and looking, only to change those ideas by altering the roles of the main protagonists. In *Dream* she becomes the object of our desire, while in *Man* he eventually becomes the captive of his own desire, thereby displacing or obscuring our own. *Man* concludes with an ambiguity about identities, so that the viewer is never certain about the nature of his or her own desire. In the very malleability of the monotype, Fischl has found a "natural" vehicle for his obsession with the interchangeability of sex, race and dominance. For in all of his work, one can never be sure who is dominant; one is only certain that dominance is a medium of human exchange. This equivalence of sexual and aggressive energies is unique to Fischl's art.

Apparently developed as a narrative about age and instinct, *Fable* is a work whose meanings appear accessible but prove illusory, and from which the viewer is left to extract his or her own moral. The series opens with the appearance of a lone, seated woman of mature years, derived from yet another nineteenth-century photograph, this time an anonymous *Nude*.[27] In the next monotype, a new space is added; the old woman is now accompanied by a female adolescent, lifted from an unforgettable photograph by George Platt Lynes.[28] Age is averted and stooped; youth is

layered aquatints of his etchings for *Foirades/Fizzles* (1975–6) with various commercially prepared abrasives.

25. The artist was not able, or was unwilling, to recall the source for this figure, which was surely a male, and possibly a work in three dimensions. Rodin's *St. John the Baptist* leaps to mind, of course, especially in the nineteenth-century context of the Eakins's model. But Fischl denies using the Rodin. It is conceivable that the inspiration was provided by one of the Edweard Muybridge studies reproduced just prior to the Eakins photograph in Constance Sullivan's book (*supra*, note 23).

26. I did not ask Fischl about another untitled series of monotypes that must have been executed at the same time as *Man*. The climactic moment of those four frames, which also depict the Eakins model, is likewise marked by the appearance of a nude woman. Rather than sculptural and heroic, she is angular and two-dimensional, wracked with contortions, and derived from a photograph attributed to Edgar Degas (one Degas used for his own paintings). See Constance Sullivan, *Nude Photographs* (*supra*, note 23), plate 31, and P. A. Lemoisne, *Degas et son oeuvre*, vol. 3, Paris, Arts et métiers graphiques, 1947, nos. 1231–4, four studies in different media from 1896–9 that included this motif.

27. Constance Sullivan, *Nude Photographs* (*supra*, note 23), plate 18. This nude seems not unlike the Bill Brandt photographs that have interested Fischl. As with the Eakins prototype, the sources chosen by Fischl have extraordinary resonances. He has remarked how they appropriate a whole age, and it is something about the meanings of these ages that hovers in the works in which Fischl employs such borrowings. "The artists of my generation feel you can borrow freely from any time and place to construct your own image. So-called pluralism means that you can locate yourself in different periods of time. My work seems to come out of the nineteenth century, but it also uses twentieth-century primitivism . . . my use of tribal artifacts is postmodernist. But I don't think postmodernism means a rejection of modernism, nor does it mean eclecticism. It's highly selective to a purpose. It really means empathizing with the myth of a stylistic period and working within that myth, re-enacting it in a new context." Interview with Donald Kuspit in *Fischl* (*supra*, note 4), p. 46.

28. *Untitled Nude*, ca. 1952, reproduced in Constance Sullivan, *Nude Photographs* (*supra*, note 23), plate 78, and discussed in Constance Glenn and Lucinda Barnes, *Eric Fischl: Scenes before the Eye* (*supra*, note 19), p. 33 and note 31. Fischl had already explored this figure in many images, including the right-hand observer of the color etchings, *Floating Islands*, 1985, and an untitled oil sketch on paper of 1985, a variation of the painting *Bayonne*, 1985 (Thomas Ammann, Zurich), of the same year. The similarities between the monotype and *Bayonne* are significant. They demonstrate the fluidity of displacement among Fischl's figures. In the painting, the elder figure derived from a twentieth-century Bill Brandt photograph (Sullivan, plate 89), whereas in the monotype she reverts to the nineteenth-century source for the monotype. Similarly, the younger figure of the painting becomes, in both monotype and oil sketch, the George Platt Lynes nude.

39

frontal, not quite self-consciously presentational. *Fable*'s third panel adds the frame of a young woman leaning over to leash(?) a running dog. She overlaps the adolescent, but whether she is to be interpreted as a metaphor for womanhood is moot. Dominance still belongs to the central Platt Lynes adolescent because of her elevated position and triumphant stance. Still, her glance directs us to the woman and dog, to the harnessing of instinct, while the older woman begins to fade, calling attention to the embrasure of a window that beckons from the background. In the final monotype, space is virtually all that remains of the old woman—an empty chair, shadows and the window attest to her death. The monotype, too, has yielded its physical substance as the inks thin out during successive impressions; the only traces of deep black, significantly, remain on the chair and the dog (Thanatos and Eros). Does Fischl, as did so many of his nineteenth-century counterparts, believe in the mediating role of the adolescent, in the androgyne who combines male and female, life and death? Attractive as such metaphorical readings may be, they rob these monotypes of their deeper poetry, which depends far more on mutability, condensation and displacement than on literary interpretations.

It is Fischl's working methods—rather than his sources, personal style or sensitivity to gesture and space—that have provided the fundamental contents of these monotypes. For the processes of growth, decline and change inform their every aspect: in the appearance and disappearance of an image as ink is added or is allowed to attenuate during successive printings; in the mutability of the figure as the new supplements or supplants the old; and in the shimmering indefiniteness of the individual spaces themselves. Not only do Fischl's figures inhabit their own psychological spaces (just as each may be derived from a tellingly different source), but in *Fable* Fischl also discovered a new kind of pictorial space. In the preparatory process of inking the linoleum surface, the multiple passes of the brayer constructed a complex, indeterminate space of transparent planes, providing each figure or frame with a penetrable depth that suggests movement, improvisation and, above all, a sense of becoming rather than of permanence. Such a space of impermanence is completely congruent with Fischl's art, and therefore appropriate for the implied cycle of changes of *Fable* itself.[29]

If *Fable* may yield to obvious interpretation, the next series of monotypes, *Beach*, decidedly does not. The former searches the past for its style, figures and content, while the latter derives almost entirely from Fischl's own photographs. Aside from the beach umbrella and mattress, the series lacks the setting and spatial coherence of similar, multi-figured paintings like *Saigon Minnesota* (fig. 4, p. 58) and *The Life of Pigeons*, 1987 (fig. 5, p. 60). Little remains for the unimaginative critic except to take refuge behind the formalist contrivance that *Beach* is simply an experiment in the logic of the monotype, an essay on pure, disjunctive change. In the very first frame an alluringly busty nude, complete with cigarette and sunglasses, turns seaward, permitting the viewer's uninhibited gaze—a gaze which, in the oil sketch, *Untitled* 1984, would have fallen on a standing male! She is joined in the second frame by another nude who lies in the sand and is accompanied by a child. The neutrality of the scene is disturbed in the third frame by the passing of a clothed male who strolls by, parenthetically (or parentally) enclosing the child and his mother(?). In the fourth monotype, two self-absorbed women—one nude, one in a bathing suit—amble through the pictorial space without in the least disturbing the non-narrative character of the image. Next, Fischl adds a Picasso-like bathing figure, whose half-hidden gesture is indecipherable, although it was appropriated from a photograph of a woman furtively pulling on her breasts.[30] Such an evocative gesture attracts only the informed viewer's attention; in fact, the entire scene is remarkable for its characters' lack of responsiveness to each other. The only compensation is that each new appearance is accompanied by the fading of an older one, like the merging images of a slide show. For example, in the sixth frame, the umbrella woman re-emerges (having been redrawn), while the remaining figures are veiled by a new space in which a boy on a raft or mattress stares intently back over his right shoulder at the viewer. Now our unimpeded gazes are caught out; their subjects have vanished into a mysterious vapor and we are left with but vague recollections. But in their stead there is the insistent presence of the boy (whose emphatic, nearly caricatural mode of depiction is unique among the monotypes and strongly reminds this writer of David Salle's drawing style).[31] In the last frame, the strolling bathers are strengthened and, at the right, an androgy-

29. "Everything takes place in the theatrical or fictional void of the stage, which signals its emotional depth or possibilities. The pictures deal with the tense relationships between people, the potential for action between them. . . . Each is a carefully calculated psychodramatic gamble that needs vast emotional space to unfold in." Eric Fischl to Donald Kuspit in *Fischl* (*supra*, note 4), p. 40.

30. Conversation with the artist, May 4, 1989. Fischl thus denied any association with Picasso's early classical bathers, and claimed that the woman derived from one of his own beach photographs.

31. Fischl had not had this association while working.

nous youth restraining a scrawny mutt has been added. Though still without narrative content, the dog's tug in the direction of the bathers and the persistent stare of the foreground boy finally engage the viewer's attention. There is so much information and so few hints as to how it might be structured: what we fantasize is obviously up to us.

The two monotypes of the eighth series, *Boy*, continue the exploitation of the layered spaces produced by rolled-on planes of ink. Whereas *Beach* seemed contemporary and intimate (if unreadable), *Boy* imparts feelings that are impersonal, academic and relatively emblematic. In truth, these figures are from older photographs: the rather chunky, erotic model—so suggestive of Matisse's figures of ca. 1907—was drawn from a 1933 photograph by André Kertész, while the lithe, puerile boy—reminiscent of Edward Weston's photographs of his son Neal—was more likely borrowed from an Imogen Cunningham photograph of 1924.[32] The relationship between the showy, older woman and the prepubescent boy is reversed in the next frame as she loses and he gains corporeality; a kneeling figure in the foreground passively observes the transition.

It is doubtful whether Fischl worked toward any clear programmatic goals during the execution of these monotypes. Rather, he proceeded to establish variations among the techniques he used, the figures he borrowed, and the changes he extracted from any given image. There are pairings of young and old, male and female, flagrantly erotic and cautiously naked, matter-of-fact caucasian and emotionally involved black, and so forth. Narrative is both parodied and contradicted by the unexpected and unexplained sequencing of frames and metamorphoses of elements. Our interpretations are metaphoric when specified by our own fantasies, but metonymic when they are suspended and allowed to remain indeterminate. If desire is the energy that fuels narrative, it is the suspension of fulfillment that drives Fischl. In his art, desire is embodied less in terms of specifiable emotions than in terms of change, dominance and eclipse. A capricious, even willful malleability of objects takes precedence over the logic of cause and effect. Accordingly, the actors on Fischl's stage have been seized from the dream day of Fischl's sourcebooks and driven by the slippery processes of the unconscious rather than by the logical structures of the composed narrative. Perhaps it is the contrasting of these two modes of thought—metaphor and metonymy—that is at the heart of these indeterminate narratives.[33] In this sense, meanings are confined much more to the surface, to appearance and association, and to the physical materials of the work, rather than to symbolic or hidden structures. What is always unknown is the artist's unpredictable will to change. Such a formulation invokes meanings far beyond the confines of the failed paradise of American suburban disillusionment.[34]

* * *

When Fischl returned to Maurice Sanchez's studio on the third of November 1986, a new monotype technique was placed at his disposal: the graphite line. Sanchez had found that certain kinds of graphite, when applied to a linoleum surface, would yield as many as ten impressions. As a test, Fischl appropriated a photograph of Sanchez's daughter, rendering her in the first plate of *Girl* with a freedom of line not unlike Rodin's. But in Fischl's world, innocence is hardly enduring. In the third monotype, the girl is joined by a dark, frenetically rope-skipping playmate, perhaps the ominous shadow of adolescence, but most assuredly inspired by two photographs from Leni Riefenstahl's incredible studies of the Nubas.[35] Materializing out of thin air, she mimics the mindless play of a child's game of jump rope, all the while suggesting the terror of the darker forces of life. The landscape setting added to the final frame of *Girl* lends an unexpected monumentality to the figures and succeeds in casting a ritualistic dread over what had begun as sheer innocence. While Fischl had not anticipated the direction his sketch of Sanchez's daughter would take, he could never pretend that his working methods do not encourage such sinister incursions. Thus in the monotypes of *Dance*, the element of radical transformation again intrudes. From one image to the other, darkness gives way to light, night to dawn, black figure to white, solitude to tethered accompaniment.[36]

to the works of Jasper Johns. See "On Being Bent 'Blue' (Second State): An Introduction to Jacques Derrida / A Footnote on Jasper Johns," *The Oxford Art Journal* 12 (1989), pp. 35–46.

34. The notion of paradise has moved, in Fischl's art, from the small dramas of the seafaring family, to the ideal of suburban order, the promised work-free warmth of the tropical island, to the nudist beaches of the Mediterranean, and the compendia of the idealized nude of the photograph.

35. Fischl showed me a special issue of the French publication *Double Page*, number 9 (1981) entitled "Noubas;" see illustration no. 13. The Nubas are a group of fairly isolated tribes living in the south of the Sudanese province of Kordofan. In particular, Riefenstahl studied the village of Kau. See *The People of Kau*, New York, Harper & Row, 1976. I would like to thank Miklos Pogany for lending me his copies of these rare publications.

36. See Riefenstahl, "Noubas" (*supra*, note 35), number 5.

32. Constance Sullivan, *Nude Photographs* (*supra*, note 23), plates 87 and 42.

33. I am very much indebted to Fred Orton's recent discussion of metonymy in relation

The main project of November 13, 1986 was, however, the series of nine monotypes called *Specter*, a continuation of Fischl's fascination with images of instinct and fear.[37] A more womanly rope dancer than that of *Girl*, seen from behind, buttocks projecting, nipples erect, is rendered with washes that evoke powerful musculature and palpable flesh. At first isolated within a plane of subtle yellow (rolled *over* the figure before printing), she emerges ever more strongly in the next frames despite the additional layers of atmospheric blue.[38] In this impalpable mist Fischl discovers a second figure, a stiff, clothed female: a statue, a bearer of offerings from antiquity, or a contemporary personage? She vanishes in the next monotype, replaced by a barely pubescent Nubian dancer—awkward and uncertain, but a mirror image of her powerful counterpart. Riefenstahl's Nubians are spellbinding. Nowhere in the annals of photography can one find such intense images of bursting adolescence. Yet these wildly erotic dances of desire were being performed for men who were ritually admonished from looking! And if chosen as husbands, would they ever again witness such acts of sexual abandon? How ironic it is, then, that Fischl soon twists his dancer toward the viewer and renders her passive, frontal, white and very Mediterranean![39] Once more Fischl exploits the monotype for changes in cultural focus, playing the "primitive" against the "classic." Tendentious as these terms may be, they embody and question the kinds of archetypal concepts with which we construct the world. What is it in our own modern culture that is fulfilled by such dichotomous embodiments of desire? What deep yearnings for unity and union are left unfulfilled?

Companion is shown here in its entirety. Again, the mood changes with the technique. The watery, rolled and graphite lines give way to heavy, slap dash washes of dark pigment. And like its counterparts, *Man* and *Fable* of the spring of 1986, *Companion* evokes a fairly translatable

narrative. A lone woman embracing a long, hanging (phallic) towel acquires a companion of sorts in the second frame.[40] Pet, man or hominoid, the very process of drawing blurred the artist's intentions. But such diffidence would hardly characterize the Nubian dancer that displaces the bather (and her towel) in the next image. Extracted from another of Riefenstahl's photographs, the voluptuous, warm brown body literally eclipses the lighter woman and the remnants of her faded, cool gray setting.[41] In the next monotype, solvent completely obliterates the two original figures, leaving globule-like clouds where living beings had once existed. The Nubian dancer towers over the primitive landscape like Goya's colossus or Cézanne's bather, and gradually acquires a lighter skin and braided hair, vaguely Polynesian. In the next three frames, Fischl develops the landscape and then rolls a curtain of gray over the figure, enveloping and containing her in a cool fog that necessitated the bonfire at the lower left. Transformed and once again infused with energy in the final frame, she becomes a rope dancer, facing us, quivering with the fragile energy of the white lines incised quickly into loosely brushed, black pigment. Such new fluidity of handling was essential to all of the monotypes of late 1986, informing content every bit as much as it did technique.

When speaking of *Companion*, the artist ruminated on an unsettling instability that often invades the act of painting: one thing becomes another before one's very eyes. Whereas an artist like Jasper Johns utilizes both immediate process and premeditated thought to determine highly rational changes in structure and meaning, Fischl simply enters into a dialogue with his lack of control. The differences are akin to the roles of the unconscious in the work of both men: the older artist appears to deny its contents, the younger appears to exploit them. And for Fischl the destabilization of painting may be felt as continuous with the lack of stability in the world, a world that is known only through representations—substitutes for what is not present and can only be desired. Accordingly, Fischl's pictorial appropriations should then be regarded as symptomatic of the constant fluidity of this linguistically constituted world. By revealing his sources, the artist may draw upon the viewer's art-historical memories, but the true purpose of his candor is, I would propose, the simple wish

37. Again the reader is reminded that only five of these are reproduced in *Scenes and Sequences*. For the other four, see the reproductions in the catalogue section of this book, nos. 70–3.

38. One of the most unusual technical aspects of these monotypes was Sanchez's ability to control the amounts of ink lifted from the plate (*i.e.*, the darkness of the image). Part of that control was exercised by the layers of tone that were applied over the image before printing. Consequently, the main figure of *Specter* progressively darkens—rather than lightens—over the first three or four impressions, without intervention of the artist!

39. Fischl confided that she was now based, appropriately enough, on a fashion photograph found in a magazine, though this writer had "mistakenly" noted something very akin to classical statuary in her winged symmetry.

40. Borrowed from an article entitled "Ruskie Business," which appeared in a periodical the artist cannot now recall. Information from the artist, March 7, 1989.

41. Riefenstahl, "Noubas" (*supra*, note 35), number 7.

to activate the viewer's free associations and thereby loosen the hold of literary metaphor.[42]

For the final monotypes of 1986, those in the series entitled *Backyard*, Fischl arrived at Sanchez's studio with a graphite sketch already on the block. Gray monochrome "washes" were added both by twisting the brayer as it rolled ink on the block and by diluted gray brushstrokes. Once again, the technique was innovative and its effect looser than anything previously attempted in monotype, although it clearly related to the thinly washed, transparent paintings of the time. The composition—seated older woman, girl with bathing suit, and dog licking itself (barely visible in the first image)—is now firmly anchored in familiar suburbia. Curiously, Fischl seems to have been at pains to find his subject, so numerous were impressions with but minor changes. In the second monotype from *Backyard*, the girl's nudity becomes just a shade less ambiguous and the background is given over to landscape, but little else of consequence occurs. Again, several pulls intervened before the next published image, in which the elder woman fades and a crouching figure is summoned up from the amorphous washes at the lower right. While probably another of Fischl's androgynous figures, the style of the hair and the focus of its gaze in the next image suggest a male. But how are we to construe this increasingly libidinous assembly that still is constituted of emphatically self-absorbed figures? In the fourth published image, there is a sudden crystallization of energies: the youthful ingenue and the older witness are summarily obliterated by heavy rolls of gray and supplanted by the daring figure of a young woman on all fours who presents a wonderfully rounded body and sensuously dark hair. If Fischl ever appropriated a figure from David Salle's erotica, she is it, though ever so much more palpable and sensual. The emphasis on her buttocks is no more new to the monotypes than was the self-contented dog whose sexuality has now been transmitted to the crouching male. In this final image, then, Fischl has allowed his preoccupations with the primitive and elemental, with sexuality unmediated by thought or convention (animal style), to take form from the watery remains of a civilized backyard. Ironically, the girl had been appropriated from the most innocent of records, a snapshot of a clothed girl unin-

hibitedly searching for something lost.[43] Far less ambiguous, however, was the title Fischl had given to the painting in which these two last protagonists appeared: *Imitating the Dog (Mother and Daugher II)*, 1984 (Collection Hugh and Lee Freund, New York).

While it seems inevitable that the figures of *Backyard* evoke thoughts of primitive coupling (front to back), or even of anal-eroticism (the title itself emphasizes the rear approach), we have preferred all along to find ultimate meanings in the transformations of imagery rather than in their static symbolism. Throughout, Fischl has consciously elided the dog's libido with fidelity, and has constantly associated the young with the dog as if it were a refuge for the victimized, the confused and the innocent. Nevertheless, he offers no assurance that imitating the dog is either natural or sinister. In a similar spirit, the artist has repeatedly compared cultural ideas: black vs. white, tribal vs. classical, male vs. female, nineteenth- vs. twentieth-century, open, loosely-worked images vs. the more closed, white-line style of traditional monotype techniques. And nowhere does one formulation emerge privileged, any more than a single style or technique has been claimed as the artist's own. As in all the arts, complexity and suggestion are entwined with economy. There are no truths in these dream images, only vehicles for self-exploration that, in their techniques and methods, uncannily mirror the methods of the imaginative mind.

43. Information from the artist, March 7, 1989.

42. So often the identification of an artist's source reveals an indebtedness, a father image, a weakness or even a hidden meaning. It has been regarded as a window into the creative act that is normally hidden from the viewer (or at least forgotten with the passage of time). With Fischl borrowing is neither a symbolic device nor an intellectual game as much as it is a scaffolding for emotional associations.

Voodoo

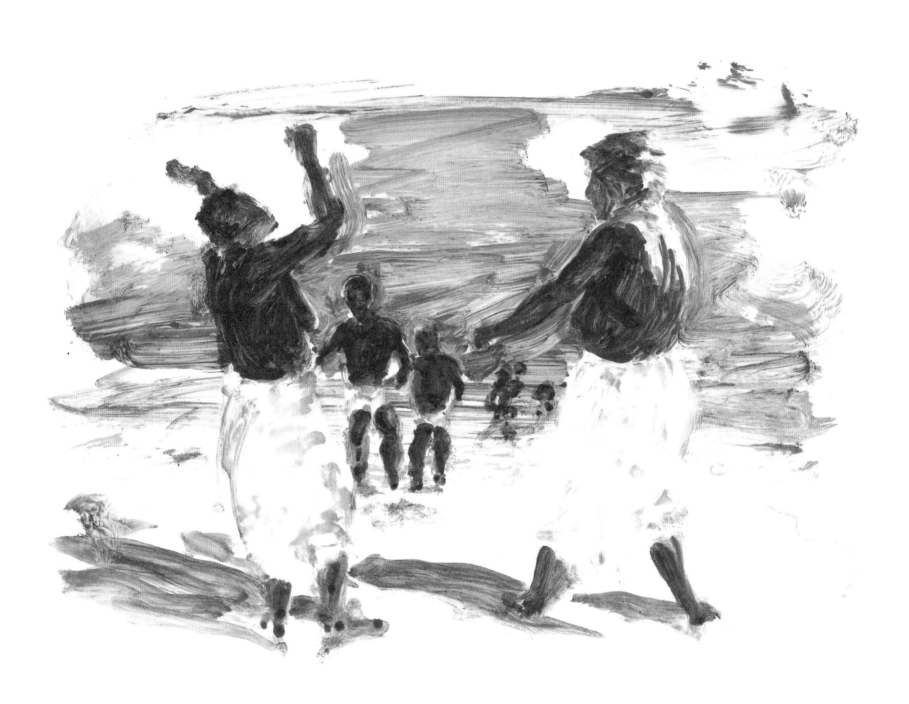

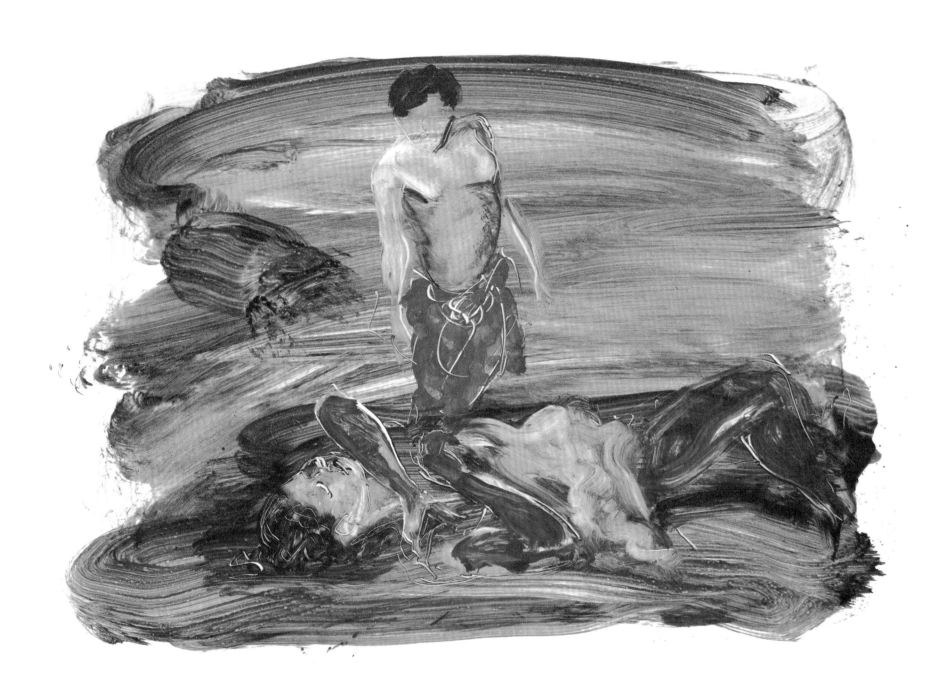

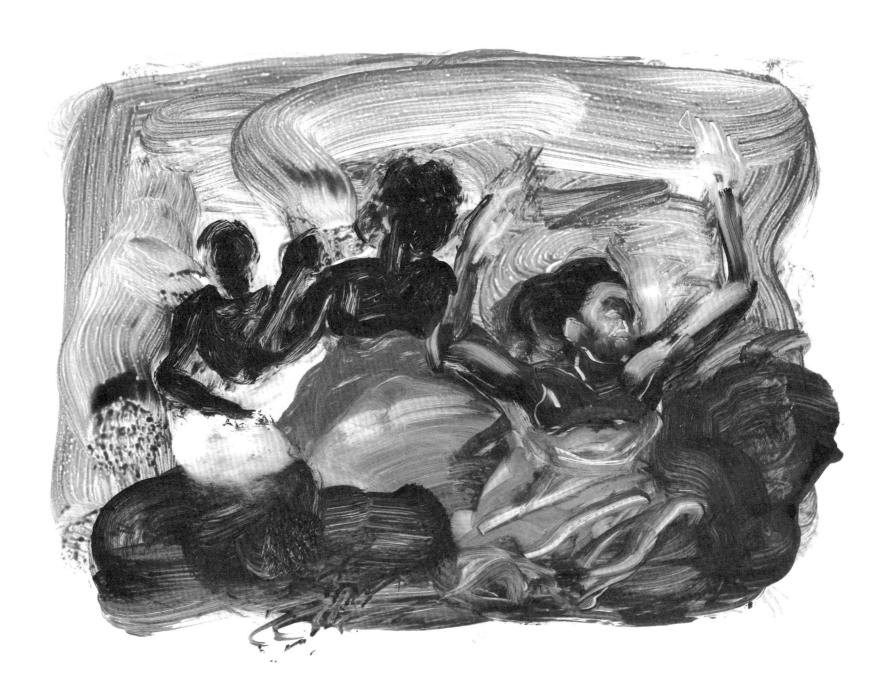

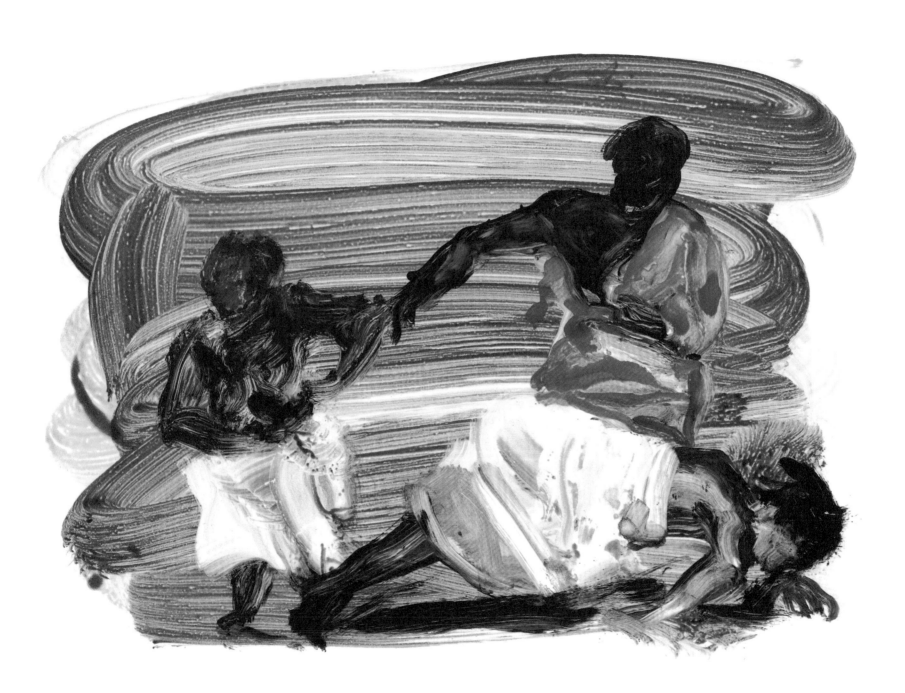

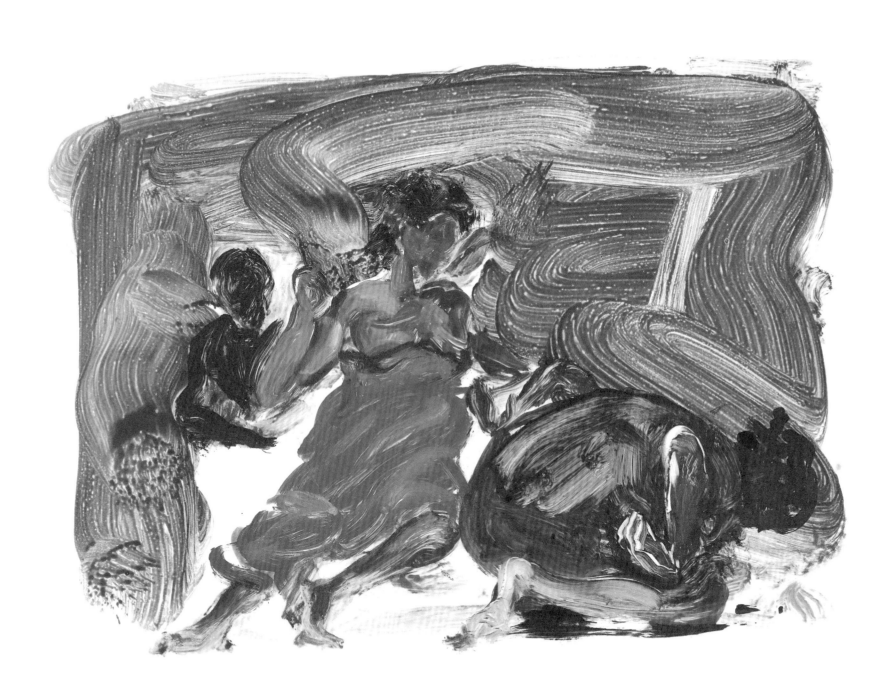

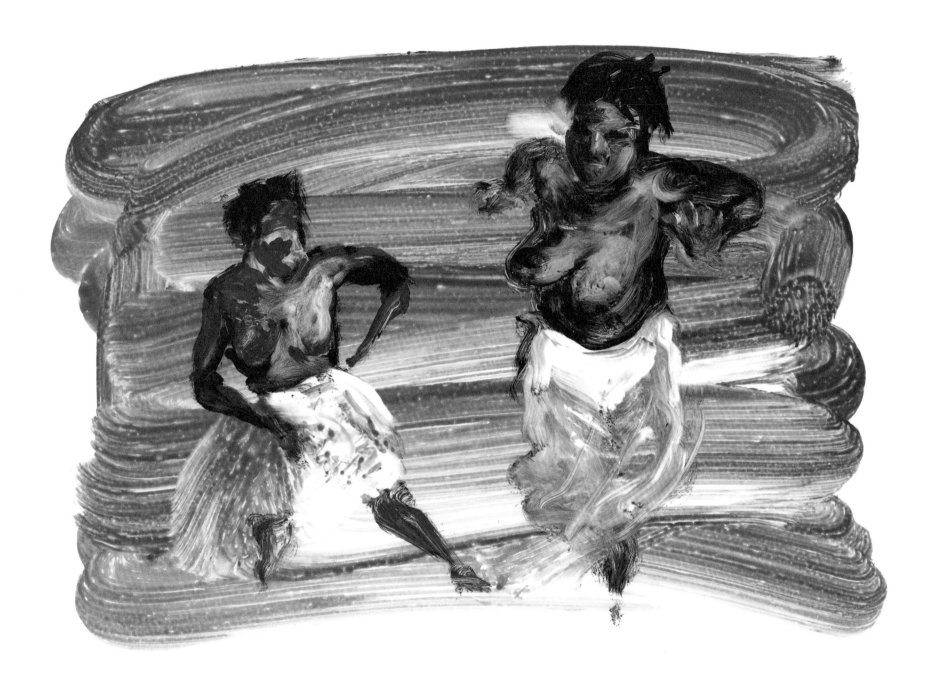

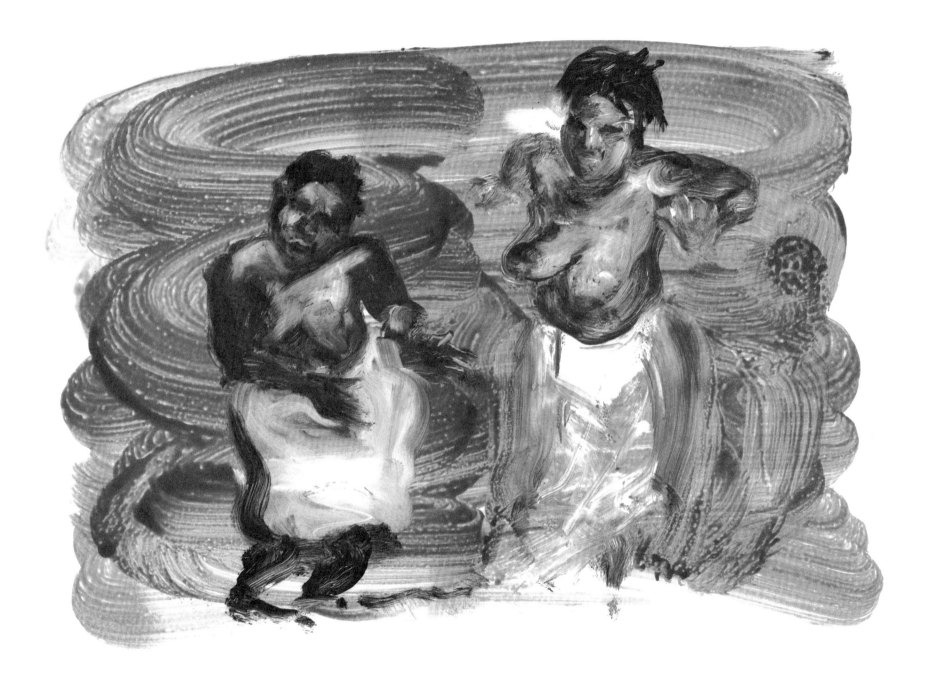

ERIC FISCHL'S MONOTYPES: IN THE CONTINUUM

Elizabeth Armstrong

Early in 1986, Eric Fischl began work on a series of monotypes that engaged him, on and off, for almost a year. When the project ended, he emerged with an extraordinarily rich body of graphic work. In contrast to the grand scale of his paintings, the monotypes are small and sequential, like quick sketches for larger, more carefully staged scenes. In this print medium, Fischl found a different, yet complementary approach to his depiction of the social landscape, another means of expressing his sense of contemporary life. Seen in relation to his paintings, drawings and other prints, the monotypes play a vital role in the continuum of his work as a whole.

Although some critics lambasted the traditional style of Fischl's first figural images of the late 1970s, his exploration of taboo subjects quickly diverted most observers' attention to this more controversial aspect of his work. He succeeded in shocking many viewers with pictures that focused on alcoholism, sexual desire, incest, and the dysfunction of the American family. Few visual artists living today have explored such disturbing subjects in their work, and fewer still have done so without resorting to caricature or satire. Fischl's approach, from the beginning, has combined critique and autobiography. He has generally depicted life among the middle and upper-middle classes, digging beneath its conventional veneer. Rarely have artists been willing to represent their own milieu with such insight and honesty.

* * *

Fischl's personal identification with his subject matter is apparent in his glassine drawings of 1978–82, in which he first stated a number of

Elizabeth Armstrong is Curator at the Walker Art Center.

I want to thank Daniel Boone, Kathleen Fluegel, and Phil Freshman for their close readings of this essay. Their constructive responses were extremely helpful to the resolution of my text.

themes to which he would later return. One of the earliest of these drawings, *The Critics*, 1979 (fig. 1), focuses on a well-to-do nuclear family: a smartly dressed couple and their young son. The parents are poised for departure, father with briefcase in hand, mother pulling on her gloves. Their adolescent son is occupied with a project of his own: wielding mallet and chisel, he squats before the figure of the boy, roughly his own age and size, whom he seems to have sculpted.

Clearly, Fischl identifies not with the parents, who seem cool and aloof, but with the artist-boy. For he has created the image of a boy cre-

FIGURE 1. Eric Fischl, *The Critics*, 1979, oil on glassine, 72 x 121 in. Private Collection. Courtesy Mary Boone Gallery, New York.

ating the image of a boy—one, a stand-in for the artist, the other, his subject. His parents, the title suggests, are stand-ins for those (in the art world?) who criticize the artist's interest in figurative imagery and, in particular, his use of the naked figure to express unconscious desires.

While the glassine drawings announced many of the provocative ideas that Fischl would subsequently pursue in his paintings, they also provided evidence of the characteristic way in which he assembled his compositions. Using individual sheets of glassine, each containing one character or object, Fischl developed his narrative by trying out different combinations of transparent "props" until he reached a satisfactory resolution or, in his words, until they revealed "the truth of that situation."[1] While much of his imagery had its source in photography, he worked subjectively, engaging in internal monologues about the figures, talking himself through the process of making them—an approach that reached maturity in the monotypes.[2]

The glassine sheets, which tend to isolate figures on one sheet from those on another, are appropriate for Fischl's depiction of the alienation experienced by people in their daily encounters. In *Saturday Night (The Aftermath Bath)*, 1980 (fig. 2), for example, the nuclear family is subdivided, each figure set apart in his or her own glassine panel. Both males (adult and child) are naked and immersed in their own activities: the man shaving, the toddler standing alone in the bath, holding his penis as if urinating into the bathwater. Sitting on the edge of the bathtub, the woman, wearing a black slip and high heels and smoking a cigarette, seems particularly removed from husband and son. Turned away from them both, she stares directly out at the viewer with a look that is at once enigmatic and emotionally complex. One might read little into the woman's expression if she were pictured alone. But with the presence of the man and the child, the image is rife with sexual and social implications. Her disengagement from this domestic unit suggests a profound dissatisfaction with the family, as such.

Fischl's way of putting together the glassine drawings facilitated his exploration of certain themes and helped him to develop his compositional and technical concerns. Although the process of evolution is not evident in his paintings, he also alters his imagery as he works on canvas, introducing elements in sequential fashion until he finds a satisfying composition. In one of his most notorious paintings of the period, *Bad Boy,*

FIGURE 2. Eric Fischl, *Saturday Night (The Aftermath Bath)*, 1980, oil on glassine, 72 x 84 in. Private Collection. Courtesy Mary Boone Gallery, New York.

1981 (Saatchi Collection, London), he reworked the image of a naked couple lying together in bed into one of a woman lying alone, her legs spread open as she casually picks at her toe. As the painting evolved, a boy was added, until in the final version, the boy is shown leaning against a dresser and facing the woman (presumably his mother), staring at her vagina while surreptitiously reaching behind and into her pocketbook.[3] Whether consciously or not, Fischl has turned the painting into an image that symbolically links desire, incest, theft, child-parent relations and possession.

In *Bad Boy*, as in many of Fischl's early paintings, the perspective is

1. The artist in a conversation with the author, April 26, 1989.
2. *Ibid.*

3. Eric Fischl to Gerald Marzorati in "I Will Not Think Bad Thoughts," *Parkett* 5 (1985), p. 21.

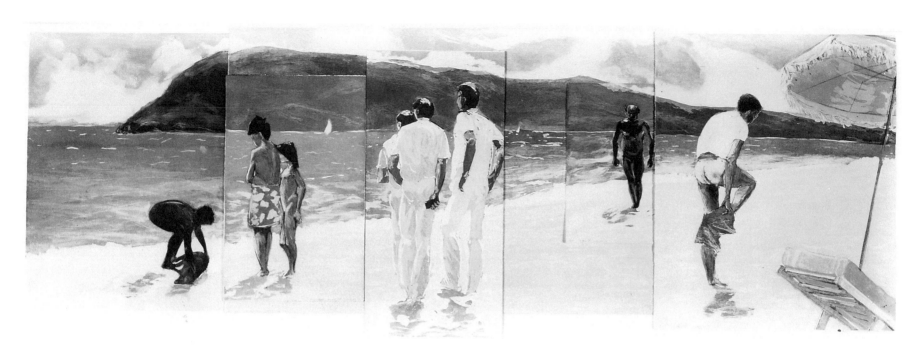

FIGURE 3. Eric Fischl, *Year of the Drowned Dog*, 1983, six color etchings, 34½ x 70¾ in. Courtesy Peter Blum Edition.

such that we feel as if we are being pushed into the scene. Too close to be simply voyeurs, our perspective is very nearly that of the boy's. Over time, however, Fischl has modified this viewpoint. One of his first prints, *Year of the Drowned Dog*, 1983 (fig. 3), for instance, has a panoramic perspective. In this portfolio of six sheets, figures are isolated as individuals or in small groups, as they were in the glassine drawings. Through its design, the portfolio gives the viewer the chance to play with the possibilities of storytelling much as Fischl himself does. When all of the sheets are laid together in their most logical sequence, the viewer surveys from left to right: a young black boy crouching over a drowned dog washed up on the beach; nearby, two children, looking on worried; three sailors, all balding, also watching; a dark, compactly built man striding toward us; and a white man, turned away from the scene on the beach, disrobing next to a beach chair and an umbrella. But the panels can be reordered in various ways to suggest different scenarios and moments in the narrative. Fischl has described the impact of the image as it appears with all the panels *except* the one with the drowned dog: "[W]hat you have is a strand of beach on which people come and go. They don't necessarily all have to be at the beach at the same time of day, or year—which is why I call it

Year instead of day or moment *of the Drowned Dog.* I wanted a protracted period of time in which people could come and walk along the beach."[4] The man walking towards the viewer could be taking "just a simple stroll down the beach. But when you put the dog in, his pace increases, you feel an urgency as he moves toward you."[5]

The imagery of this print broaches a sub-theme that also began appearing in Fischl's paintings of the period: that is, the conjunction of cultures and races found especially in tourist countries. In a canvas entitled *A Visit To / A Visit From / The Island*, 1983 (Whitney Museum of American Art, New York), a tropical beach is the stage for a set of dramatically disparate experiences. On the left, the beach serves as a playground for vacationing tourists, who play listlessly in the turquoise waters; on the right, it is the scene of profound grief as native islanders pull drowned bodies out of the dark, turbulent sea. This juxtaposition results in one of Fischl's

4. Constance W. Glenn and Lucinda Barnes, *Eric Fischl, Scenes Before the Eye*, exhibition catalogue, University Art Museum, California State University, Long Beach, California (1986), p. 13.
5. *Ibid.*, p. 14.

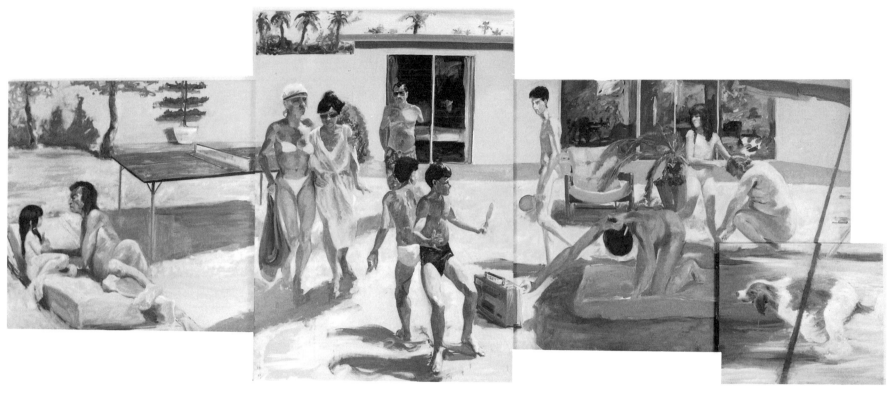

FIGURE 4. Eric Fischl, *Saigon Minnesota*, 1985, oil on canvas, 120 x 297 in. Collection Robert and Jane Meyerhoff, Phoenix, Maryland.

more explicit social statements, calling to mind lyrics from the Sex Pistols song, "Holidays in the Sun," in which they intone: "Your holiday in other people's misery." The idea of "the vacation" as a form of displacement is related to Fischl's theme of alienation in the American family. Here, as in suburbia, a presumed idyllic setting becomes the site of false promises and failed dreams. The numbed lethargy of the vacationers further underscores Fischl's perception of general malaise in American society.

Fischl ultimately applied the narrative complexity of the two-part *A Visit To / A Visit From / The Island* and the six-part *Year of the Drowned Dog* print to *Saigon Minnesota*, 1985 (fig. 4), the first of his multi-paneled paintings. This large four-part canvas brings together a disturbing composite of elements, including eleven people and a dog, presented in a chaotic range of gestures and poses. According to Fischl, the title occurred to him after some of the figures began to take on an Amerasian cast. In addition, as he was working on the painting, the national press was re-

porting a scandal in a small Minnesota town that involved alleged child abuse.[6] The juxtaposition of clothed and unclothed figures, children and adults, caucasians and Amerasians, and the presence of the disabled figure, (the one-armed man at center), evoke many disturbing associations, including the Vietnam War and increased reports of sexual abuse of children in this country. But just where the scene is supposed to be, and exactly who the people in this painting are, is no more apparent from the imagery than from the title. Rather than identifying with anyone in the painting, Fischl seems to be keeping his distance from this large and complex composition.

In the view of art critic Peter Schjeldahl, *Saigon Minnesota* is a transitional work in the artist's *oeuvre*, signaling "a kind of Copernican shift, a

6. Peter Schjeldahl, *Eric Fischl*, New York, *Art in America* and Stewart, Tabori & Chang (1988), p. 27.

displacement at the center of gravity from inside to outside the picture. The change is from scenario to tableau, from the personal to the social, and from obsession to ambivalence."[7] In paintings such as *Saigon Minnesota*, Fischl's perspective is that of the child grown up, laden with unwanted knowledge and self-consciousness. The renderings of the figures themselves are as formally unresolved as their personal relationships and circumstances, leaving the viewer faced with a morass of social confusion and moral ambiguity.

<p align="center">* * *</p>

At the same time that Fischl was working on such major canvases as *Saigon Minnesota*, he was also engaged in making more intimate views of everyday life. Through the 1980s he made small oil paintings, from which many of his larger images developed. These reveal his increasing mastery of the figure and have a spontaneous, washy feel that resembles the look of monotype. Considering this similarity, it is hardly surprising that Fischl would soon think of making monotypes or that he would become so adept at handling the monotype process.

The intrinsic qualities of the monotype no doubt attracted Fischl as they allowed him to alter his sketches with a minimum of effort and enabled him to capture the nuances of a figure's gesture and pose. The monotype process also permitted him the chance to deal with subject matter in a new way, by allowing him to emphasize and exploit the sequential nature of narrative—something only implied in his previous work. This was surely one of the technique's strongest attractions for him.

For example, in the first series of monotypes a man follows a woman down the beach. In each of the first four prints in this sequence, entitled *Stroll*, the figures change in subtle ways—not only in their positions and strides but in their body shapes as well. They seem to grow older and heavier, as if this same scene is being re-enacted over a period of years. Here, Fischl gives visual form to the theme of desire which he so often mined in his earlier works. But it is the inability to attain the object of desire—the fantasy of possession, rather than its reality—that charges the scene. As if to confirm that notion, the woman fades from view in the last print of the sequence.

The dreamlike appearance of these first monotypes is carried throughout the remaining series: figures appear, temporarily assert themselves, then dissolve—much in the way, Fischl says, he pictures images in his

mind.[8] Using the same printing matrix, he could quickly alter these figures or, by adding new figures without removing the old, allow them to become "ghost images" before disappearing altogether. The challenge of depicting the imagery within a limited period of time forced him to concentrate more on technique than he usually would. Ironically, the speed required of the monotype process may have given him a certain freedom. Instead of questioning or repressing his imagery, he was more concerned with trying to figure out how to make it and was more apt to derive his imagery from free association.[9]

This enforced spontaneity would perhaps explain the evolution of his second series of monotypes, *Voodoo*, which seems slightly out of place in a body of work almost entirely fixed upon contemporary American culture. While Fischl has touched on the gulf between Western and non-Western cultures in such paintings as *A Visit To / A Visit From / The Islands*, he has rarely focused exclusively on the latter. Yet for a white, Western artist, the rituals of a black African religion are subjects that are no less taboo than those of masturbation and incest.

The series is based on photographs from a book on African voodoo. With these in mind, Fischl imbued the figures of black women with tremendous vitality, rhythm, and erotic power. Given that this is a stereotypical view of blacks by whites—and Fischl has certainly considered this[10]—these images represent a remarkably uncensored, subjective expression. His willingness to expose himself (in a way that recognizes his complicity with the attitudes he critiques) gives the work much of its validity and power.

One of the more significant changes in Fischl's art in recent years has been the way in which he depicts the human figure. His early renderings were self-consciously awkward, as if to acknowledge his own discomfort with figurative art. During the 1980s, however, his mastery of the figure increased significantly, and the monotypes reveal his sheer pleasure and skill in rendering the human form. One of the most beautiful examples of his figure drawing can be seen in the *Girl* series. In the first print the image of a small, kneeling child is isolated on the sheet, her delicate form delineated by an economy of sure strokes and given volume with a quick, gestural wash. Next to her elegantly rendered form are two sketchy marks

7. *Ibid.*, p. 28.

8. *Supra*, note 1.

9. *Ibid.*

10. In response to a question about the portrayal of blacks in some of his paintings, Fischl was quoted as saying that "They are stereotypes, cultural stereotypes having to do with sexual prowess, the exotic, whatever." *Parkett* (*supra*, note 3), p. 27.

FIGURE 5. Eric Fischl, *The Life of Pigeons*, 1987, oil on linen, 117½ x 292 in. Saatchi Collection, London.

that seem to insist on the spontaneity with which line becomes image. In the second print in the series, the marks have disappeared and the girl is more fully described, with a light blue wash behind her to suggest that she is outdoors. In the next image she is joined by an older, black girl with a jump rope. The second figure has a slightly ominous presence, perhaps because of the shadow she casts over the smaller child. The sudden juxtaposition of the two figures completely alters the feeling of the image, much in the way that a random interaction can suddenly alter one's life. As is often the case in Fischl's scenes, the tension is implied; one only senses that the little girl's playing will be disrupted by the older child with the jump rope. Learning that the next series in the chronology of the monotypes, *Specter*, begins with a black woman wielding a whip does little to allay the feeling of menace.

In the *Man* series Fischl again introduces a second figure whose presence dramatically alters our perception of the scene. In the first three prints in the series we see a male nude depicted in the style of a typical nineteenth-century figure study. It is, in fact, based on a photograph by Thomas Eakins, used by that artist in the painting of *The Swimming Hole*, 1883 (Amon Carter Museum, Fort Worth). Fischl seems to revel in his own fluid portrayal of this figure, which he depicts in three separate vignettes. Our delight in viewing these sensuous figure studies is disrupted in the fourth print, however, in which the presence of a gyrating female form completely changes the mood. Like the dog in *Year of the Drowned Dog*, the woman in *Man* qualifies the scene. Instead of being situated in a neutral setting (like the artist's studio), we become aware that the scene takes place in a motel room or a boudoir. With the addition of the final image in the series, the sensual imagery becomes sexual.

As Fischl worked at refining the monotypes technically, he also found a way of complicating their narratives. Among the most complex and ambiguous of these is the sequence entitled *Backyard*. The first image portrays three images in a triangular format: a naked, heavyset woman sitting on a sunning mattress; a young girl, also naked and holding her bathing suit aloft in her left hand; and a dog, twisting around to lick itself. As the series progresses the older woman and the dog start to fade away,

and the image of the young girl is intensified. She is joined by a crouching man. He also appears to be naked and, in such close juxtaposition to the young girl, raises the possibility of sexual abuse also hinted at in *Saigon Minnesota*. In the next image in the sequence, a third female figure replaces the other two. Undressed and on all fours, her position and proximity to the crouching man is explicitly sexual, as the scene moves from the backyard to the bedroom.

*　　*　　*

Fischl has said that because of their scale and difficulty, his paintings lag somewhat behind his graphic work.[11] It was in *Year of the Drowned Dog*, for instance, that he first used multiple panels that were opaque—an approach he would try in his paintings only two years later. Similarly, the sailors who first surfaced in this print reappeared in the 1984 painting, *Cargo Cults* (Ludwig Museum, Cologne). One can only speculate on the impact of the monotypes on Fischl's paintings; with their richness of imagery and technique, they seem likely to stimulate significant new work. In fact, the year following the monotype project was a particularly productive one for Fischl in which two new multi-paneled paintings, *The Life of Pigeons* and *The Start of a Fairy Tale*, both 1987 (figs. 5–6), were generated by the *Backyard* sequence alone.

In *The Life of Pigeons* Fischl gives each figure its own canvas panel. The older woman, whom he introduced in his first print in the *Backyard* series, is still engaged in the awkward effort of pushing herself up from the mattress. At the far right, a dog splashes toward the figures in the foreground. The crouching man, quietly slipping into the water, seems even more ominous than in the monotypes, perhaps because of his mirrored aviator glasses. The woman sunbathing on her back in the small boat may be a new character or could be the one seen from behind in the monotypes. Like the pigeons in the lower left of the painting, she seems impervious to the surroundings, temporarily suspended in the heat and stillness of a late summer day, but imminently threatened by man and dog.

And what of the young girl in the *Backyard*? She is the focus of *The Start of a Fairy Tale*, one of Fischl's most poignant paintings. The evolution of the artist's technical skills is fully apparent in this virtuosic work, as is the change in his perspective. This girl, unlike the young boy in *The Critics*, reflects an adult's nostalgia for childhood. Crossing a tightrope strung between two trees, she maintains a delicate balance between being

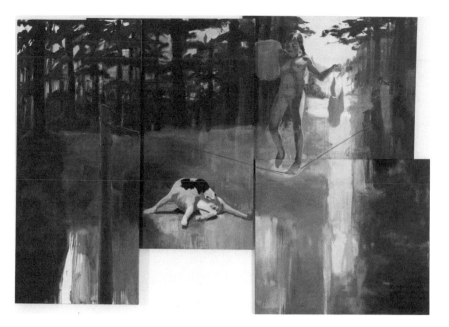

FIGURE 6. Eric Fischl, *The Start of the Fairy Tale*, 1987, oil on linen, 114 x 166½ in. Collection Irma and Norman Braman.

subject and object, between youthful innocence and adult sexuality (a transitional state in which many of Fischl's figures are caught). And, as in many of Fischl's best images, there is a sense of foreboding about the picture—not because we are afraid she will lose her balance but because of the inevitability of a more profound loss. Her state of grace, Fischl insistently reminds us, must soon come to an end. Still holding her bathing suit aloft in one hand, "like a shedding of the skin,"[12] the girl is, in the artist's words, "completely unaware of her emerging beauty and desirability."[13] The child has no human foil to threaten her—only the personal associations of the artist and the viewer.

While *Start of the Fairy Tale* is certainly open to such a psychological reading, it is less overtly sexual and anxiety-ridden than most of Fischl's canvases to date. The painting is so technically accomplished that the impact of its style rivals that of its subject. The young girl's form is exquisitely rendered, as is the surrounding landscape, which dissolves and slides into a luminosity that gives the entire painting a romantic glow. There is, too, in the painting a sense of closure. For here Fischl has taken a style and technique born of necessity in his earliest work on glassine—which he expanded and refined in his exploration of the monotype—and made it a matter of expressive choice.

11. Constance Glenn and Lucinda Barnes, *Eric Fischl: Scenes Before the Eye* (*supra*, note 4), p. 21.

12. *Supra*, note 1.
13. *Ibid.*

PRIVATE PLEASURES: FISCHL'S MONOTYPES

Carol Zemel

In an age of sexual anxiety and risk, Eric Fischl's pictures about desire and sexuality are both provocative and unsettling. Images of a naked man fondling his toddler daughter or a woman masturbating before a teenage boy are meant to shock as well as stimulate. Their pictorial strategies are no less disturbing. The realist staging of paintings like *Daddy's Girl*, 1984 (Collection Robert and Doris Hillman), *Sleepwalker*, 1979 (Thomas Ammann, Zurich), or *Master Bedroom*, 1983 (The Museum of Contemporary Art, Los Angeles), for example, implicate viewers in the scene, making us responsive participants in the erotic activity on display.[1] And multi-panel works such as *Bayonne*, 1985 (Thomas Ammann, Zurich) or *Saigon Minnesota* (fig. 4, p. 58) add a psychic dimension, as they frame and protract the moments of desire. With their preferred locations the bedroom and the beach, these scenes of middle-class affluence and leisure hover between pornographic fantasy and credible event.

But Fischl's pictures have also been criticized by audiences variously discomforted by the display of women's bodies, by the apparent picturing of transgressive sexual acts—incest, bestiality and by the projection of sexual object-ness onto conventional signifiers of raw appetite and power-lessness: women and black men most notably, as well as teenagers and dogs. The cultural politics gathered under this critical umbrella range from gender and race-sensitive positions to pro-censorship stands. The first two objections—the erotic display of bodies and the picturing of sexual acts and fantasies—are part of the protracted debate on sexual representation

and censorship. These issues are currently rendered all the more pressing by the Helms Amendment and the threatened withdrawal of funding for art that transgresses narrow definitions of decorum and good taste. Without diminishing the urgency of that discussion, and from my own position as a middle-class white woman, I want to consider the third contention and argument: the issue of objectification and projected otherness, specifi-cally as it applies to gender and race as depicted in the monotypes, *Scenes and Sequences*.[2] I will frame the issue in anthropological terms: what is the sexual ethnography depicted here, and how is it formulated? What notions of "normalcy", or alterity, do the monotypes inscribe? How do their depictions of women and persons of color mark out a terrain of fixed and distanced otherness? And given the middle-class patronage for which they are undoubtedly intended, what kind of viewer subject positions do they invite or disallow? By consudering the context in which they are seen, as well as their design and content, we may probe the constructions of gender, race and sexuality in these prints, and unravel the pleasures, dis-comforts and empowerments they provide their spectators.

In their current presentation, the monotypes replace the public access and scrutiny of museums and galleries with a private and contemplative viewing experience. The book format provides the kind of armchair inti-macy traditionally associated with the refined pleasures of Japanese prints

Carol Zemel is Associate Professor of Art History at the State University of New York, Buffalo.

1. For discussion of Fischl's and other artists' manipulations of viewer subject posi-tions, see my "Post-modern Pictures of Erotic Fantasy and Social Space," *Genders* 4 (Spring 1989), pp. 26–49.

2. There is considerable literature in several disciplines—anthropology, history, art history and film studies, literary criticism—on this issue. Three interesting and helpful dis-cussions are : Craig Owens, "The Discourse of Others: Feminists and Postmodernism," in *The Anti-Aesthetic*, Hal Foster, ed., Seattle, Bay Press, 1985, pp. 57–82; the "Global Issue" edition of *Art in America* (Summer 1989); essays on "the new ethnography" in *Writing Culture; The Poetics and Politics of Ethnography*, James Clifford and George E. Marcus, eds., Berkeley, University of California Press, 1986, and the feminist critique of that position outlined by Francis Maascia-Lees, Patricia Sharpe, and Colleen Ballerino Cohen in "The Postmodernist Turn in Anthropology: Cautions from a Feminist Perspective," *Signs* (Au-tumn 1989), pp. 7–33.

or Persian miniatures, or with the satisfactions of modern pornography. Indeed, the prints enjoy some of both worlds, combining the permissions of pornographic fantasy with the loftier credentials that high culture implies. But unlike the pornographic photograph or even a realist painting, where evidence of the making of the illusion is magically sutured away, the monotypes keep Fischl's technical virtuosity constantly in view. Their fluid handling, with the push and drag of fingermarks through luminous and puddled inks, keeps us mindful of the pictorial process and offer a sort of privileged share in the artist's skillful imaginings.

For all of its gratification, this is a much different experience than the participatory demands of the paintings, whose raking perspectives and spatial intrusions—protruding beds, terrace planters—engage the viewer as a responsible witness-participant. The monotypes unfold before us as a closed and separate realm, leaving the viewer comfortably detached and our voyeurism undisturbed. For example, *Scenes and Sequences* is staged quite literally across a woman's body. The book begins and ends, as it were, with images of a nude woman reading in a windowed bedroom. Appropriately titled *Dream*, these views into a heavily curtained interior proclaim a conventional site of sexual fantasy: the reading / daydreaming woman, whose body and imagination are laid out for us to possess. In the present context, she is also an objectified companion for the book's reader, and so frames the touristic sequences and erotic imaginings within. Thus, if the oil paintings problematized the viewer's spectatorial participation in contemporary sexual games and fantasies, the monotypes in contrast leave the viewer's position seemingly intact. We watch the pictured realm of fantasy as if our particular and socially constructed positions were universal and natural, which of course they are not.

Simple washes of color transform the class-marked settings—the hotel terraces, bedrooms, pools, beaches and yachts—of Fischl's paintings into landscape signifiers of primordial nature: a cavernous darkness, a pale blue haze, a stretch of grass or beach. If social positions and responsibilities are evacuated by this primitivizing return to nature, some of that resonance remains in the figure types and postures. They are sexy and direct, with a wet, visceral presence that befits the juice of the medium. Fischl pushes the ink around to sculpt a muscular haunch, a bobbing breast and protruding buttock. But nudity too, after all, provides cultural costume and identity. The smooth-limbed beach nymphs in *Beach*, *Backyard* and *Dream* are familiar objects of narcissistic display. Pendulous-breasted women, gangly boys, and paunchy men (*Backyard*, *Beach*, *Stroll*) are more exaggerated, mannerist stereotypes. If this ironic "naturalizing"

of middle-class sexual types is Fischl's project, the ground starts to shift precariously when "other" people move to center page. For here the critique of the dominant culture's erotic habits and pastimes is replaced with fixtures of a white male sexual and cultural fantasy. Monumental, statuesque figures (*Voodoo*, *Dance*, *Specter*, *Companion*) common to the modernist repertoire appear and occasionally encounter the suburban company. These dark-skinned men and women are relatives of Cézanne's and Matisse's bathers, Picasso's primitive nudes, Nolde's exotic dancers. Sanctioned by their status as cultural icons, they invoke for white middle-class viewers familiar notions of fecundity, sensuality and appetite.

Reinforcing these cultural fictions and social stereotypes is the prints' arrangement and design. Fischl exploits the properties of monotype through repetitions and formal transformations of trace images left after the single impression is made. Arranged in sequences, the prints page by like a series of stop-action photographs that record change but not process. It is almost an inversion of conventional cinematic story-telling, where, as Laura Mulvey has described it, the realist narrative is interrupted and voyeuristic pleasure intensified by an iconic close-up of a woman's face.[3] The monotypes, in a sense, perform the very opposite function, and unfold as a series of icons or emblematic tableaus. Rather than a realist narrative, the effect is a sense of framed fantasy or dream.

But no matter how distilled or condensed their structure, sequences suggest stories: from the sexual stalking of *Stroll*, to the orgy of nude sunning and spectacle in *Backyard*, and the group of vacation types who gradually crowd the prints in *Beach*. These are minimal tales. They stage the visual fascinations and mysteries of fantasy: we see, we think we see, we glimpse; objects transform, person becomes specter, ghost figures give way to other members of the cast. Sequences stop without resolution or closure, in a sort of post-modern refusal to settle narrative expectations or to explain transformations and events. Simply described, these are the scenarios of the middle-class vacation; their cast of characters and narrative coherence is authorized by modernist iconographies of exotic cultures and gendered otherness.

Without simply being prudish, many viewers are bound to question the assumptions about sex, race and gender installed here. Can we innocently return, even in the privacy of the art book, to modernism's timeless,

3. This fundamental essay, "Visual Pleasure and Narrative Cinema," *Screen* (1975), reprinted in Laura Mulvey, *Visual and Other Pleasures*, Bloomington, Indiana University Press, 1989.

exoticized sensualities and "natural" passions? We do so only by willfully ignoring contemporary gender, race and sexual identities, the urgency of those claims, and some of the very issues of spectatorship and responsibility that Fischl's oil paintings so forcefully put into play. Is the space of private contemplation so removed from public discourse, so cushioned and insulated that we can set aside our own identities as subjects, accept the pleasures of Fischl's virtuosity, and bask in the universalized voyeurisms of a previous century?

Let's consider more closely just who and what is represented for the viewers of these images. Fischl's beach and bedroom population is little changed in the monotypes. There are a few white men around, with conventional sexual habits. One fellow stalks a straw-hatted woman; another strolls in shorts and shirt-sleeves past a group of sunbathers; another recoils from a black woman's whip. Among the more unruly signifiers of sexual appetite, adolescent boys have also tamed their sexual hijinks, and the vulnerability that marked their appearance in Fischl's paintings has all but disappeared. One young man crouches down in *Backyard* to leer, along with the spectator, at a kneeling woman's proffered rear. Another turns from the center of *Beach* to stare curiously back at us. Largely voyeuristic in their activities, paunchy, chicken-chested, and faintly ridiculous in form, these are hardly macho figures of potency or authority.

But if Fischl refuses to celebrate the conventional representatives of masculinity, women appear in familiar objectified positions. Sunbathing nude, dancing, kneeling or serving a black amazon, they are always the center of spectacle. Indeed, the one example of sexual activity in the monotypes is about that kind of looking: the spectacle, in *Man*, of a male nude watching a woman masturbate before him and, when she appears in the fourth print, before us. This constant positioning of women as the object of some desiring gaze metaphorically describes the masculine viewer's relation to a feminine other: she is always set at some distance, to be enjoyed erotically without threat of emotional intimacy.[4]

People of color appear in a variety of social roles in Fischl's pictures, occasionally as agents of unsettledness. The interracial couples and vacation groups in the paintings *St. Tropez*, 1984 (Private Collection) and *The Brat II*, 1984 (Saatchi Collection, London) report a rather integrated sexuality, while a slip-clad maid bathing a grotesque toddler in *Help*, 1980

(The Rivendell Collection) describes the racial bases of middle-class domestic labor. But other paintings, set farther from the American scene are more confrontational. They report, at times with didactic obviousness, the tensions, anxieties and race hate in segregated societies. Thus, *A Visit to / A Visit from the Island*, 1983 (Whitney Museum of American Art, New York) divides the oceanside into separate zones of white pleasure and black tragedy. The atmosphere changes considerably in *Cargo Cults*, 1984 (Ludwig Museum, Cologne), where a party of American white men (their Pan-Am bag decorates the foreground) hoot at two passing black girls and are threatened by a caftaned figure bearing a knife. The centrality of whites in these pictures signals the imperialist presumptions of our habits as tourists—the way in which we are always more and rarely less than "at home" in the world. While white Americans in these confrontations are hardly benign figures, Third World people are depicted as bearers of particular projected differences—the mysterious forces and potencies associated with another, "native" world. And in the monotypes, they are even more firmly locked into stereotypical otherness.

The series *Girl* depicts an androgynous figure wielding a jump rope like a whip over a kneeling blonde girl. She in turn straddles the black woman's shadow, and the composition evokes a troubling ambience of dominance and power between women and races. The mood continues in *Specter*, where a full-breasted black woman with a whip in her upraised hand takes shape in a watery blue atmosphere where she is approached by a white woman in a dress. Each figure then undergoes a race and gender change: the white woman becomes a wizened nude white man, while the black dominatrix pales to white nudity, and her whip becomes a blowing towel or drape. Most disturbing is *Voodoo*. Here a group of sarong-clad "native" men and women supplant a white man and cluster together in an agitated ritual. These are fantasies of course, not documentary events. They are bound nevertheless to traditional, naturalizing inscriptions of racial sexualities and racial potencies. Indeed, their wetly smeared bulbous torsos recall the jarring, heathen appetites of Emil Nolde's *St. Mary of Egypt*, 1912 (Kunsthalle, Hamburg) or *Candle-dancers*, 1912 (Nolde Fondation, Seebüll). As primitive exotics full of power and aggression, they, too, secure the limits of bourgeois cultural iconography.

The question becomes: can an artist today represent—and can viewers see—other sexualities, other peoples, without acknowledging his or her stake in that particular or exoticized form? What of the sexualities and social worlds the artist and viewers do not share but can only fantasize about or see at some distance? In one of modernism's most disruptive

4. The lesbian and homosexual relations suggested in paintings like *Father and Son*, 1980 (Collection Edwin L. Stringer, Q.C., Toronto), *Untitled*, 1982 (Collection Susan and Lewis Manilow), or *Sisters*, 1983 (Private Collection) is missing from the monotypes.

images of sexual, class and racial otherness, Edouard Manet represented Laura, a black woman, as the prostitute Olympia's maid.[5] Laura's rotund form and dark skin is not only a deliberate contrast with Olympia's whiteness, her presence as an Afro-European served to intensify the sexuality on display.[6] And like Olympia, she too is veiled by the conditions of commodification: their persons erased and hidden; their culture and bodies for sale. As Manet's carefully costumed and furnished picture tells us, neither position is "natural;" both are constructions of nineteenth-century culture. Indeed, the painting stages and renders problematic the very notion of sexual and racial "naturalness."

Fischl's responsiveness to Manet's sexual ironies is evident in paintings like *Master Bedroom*, 1983 (The Museum of Contemporary Art, Los Angeles) where he conflates Olympia's maid and cat into a teenage girl's pet dog and possible sexual partner. Indeed, Fischl's troupe of canines, from frisky terriers to restless dalmations and big black labradors, make a variety of appearances, but always as partners or sexual surrogates. The monotypes continue the animalizing strategy in *Companion*, a two print sequence where a nude woman, seated like Victorine Meurent in Manet's *Luncheon on the Grass*, 1863 (Musée d'Orsay, Paris) but without her challenging stare, is joined by a watchful black dog.

Yet despite the pictorial tip of the hat to distinguished predecessors, and the efforts at racial encounter in the paintings, the monotypes simplify their construction of race relations. Unlike the vacationers, people of color in these monotypes seem to be beyond time and place. They come from nowhere in particular—from nature, the beach or cave. They are not African, or Afro-American, or Caribbean (despite the title of *Voodoo*). They fit older western designations: negro, native, black. The recurring gender and racial exchanges might weakly qualify as a homogenizing elision of difference, or some multi-colored "humanism" in a pictorial search for origins, but this hardly accounts for their aggressive content. Rather, they exist in nature as emblematic projections of unrepressed sexuality, pent-up aggression, sacrificial rites. And their pre-civilized condition is a familiar

and hackneyed cultural myth. With little evidence of the power relations and vulnerabilities that animated the paintings and set up their critical mode, the monotypes present the stasis of conventional opposition: black figures and women fixed as natural essences for the gaze of a detached spectator. What we have is not an ethnographic pluralism, but a familiar white male fantasy in which some of us are all too easily inscribed.

There is, to be sure, no right way to represent an other, at least not without declaring the basis of that representation in the bourgeois imagination. To do so would also change the grounds of the issue and remove it from a familiar framework. It would put some dialectical set of gender and race relations into play, and so move otherness from this fixity to more mobile axes of difference.

What has been remarkable in Fischl's pictures is their critical representation of the sexual appetites, desires and activities of American masculinity, and the self-conscious inscription of the spectator in the display of that sexuality. As it actively engages the viewer, the work not only makes point of view and looking part of the picture's meaning, it also allows a range of subject positions and makes room for comment and critique. When that position is universalized, as it pretends to be in the private book experience of *Scenes and Sequences*, when the spectator is seemingly disengaged and relegated to the safety of invisible voyeur, then the ground of representation becomes a closed and absolute field. That done, it is crucial to map the images' gender and color lines. Within the closed framework of bourgeois desire as the monotypes represent it, the fantasies of otherness are fixed and unchanged.

5. Except for Sander L. Gilman's discussion of the painting's racial and sexual implications ["The Hottentot and the Prostitute: Toward an Iconography of Female Sexuality," in *Difference and Pathology, Stereotypes of Sexuality, Race, and Madness*, Ithaca and London, 1985] and Theodore Reff's brief mention of her name [*Manet: Olympia*, New York: The Viking Press, 1977], she is rarely discussed by historians and, it seems, is scarcely seen.

6. She functions in this sense like the cat at Olympia's feet. Both figures, prostitute and servant, are assumed to share a bestial sexuality. Sander Gilman discusses the animalized perception of African sexuality "Hottentot and Prostitute" (*supra*, note 5).

Beach

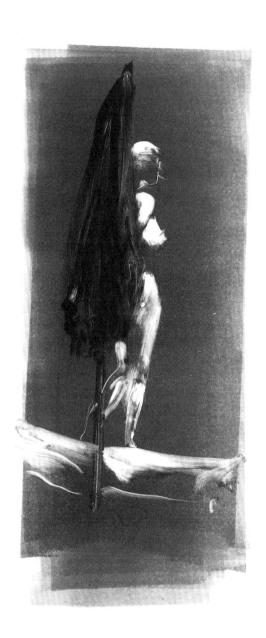
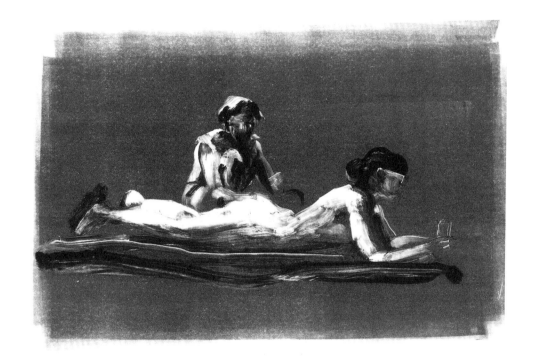

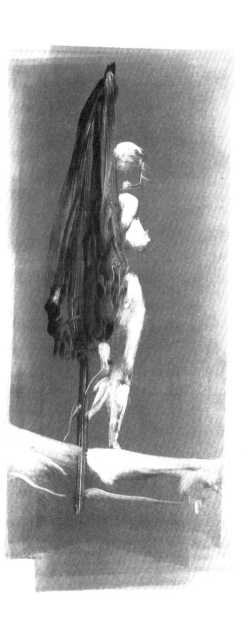
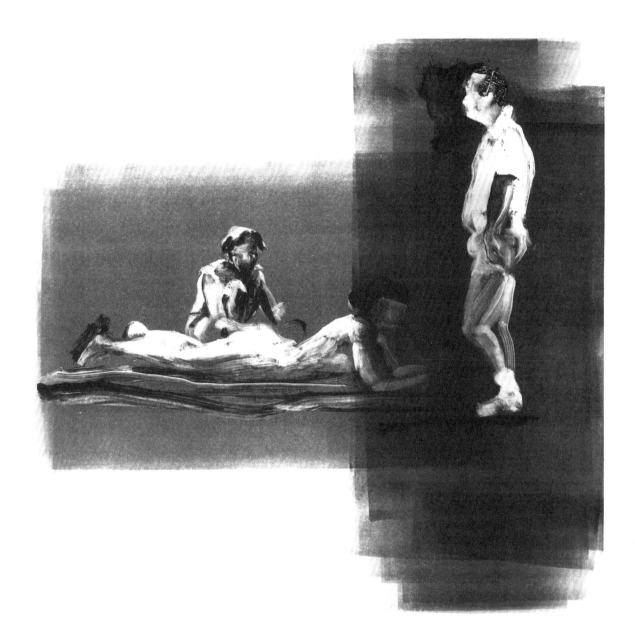

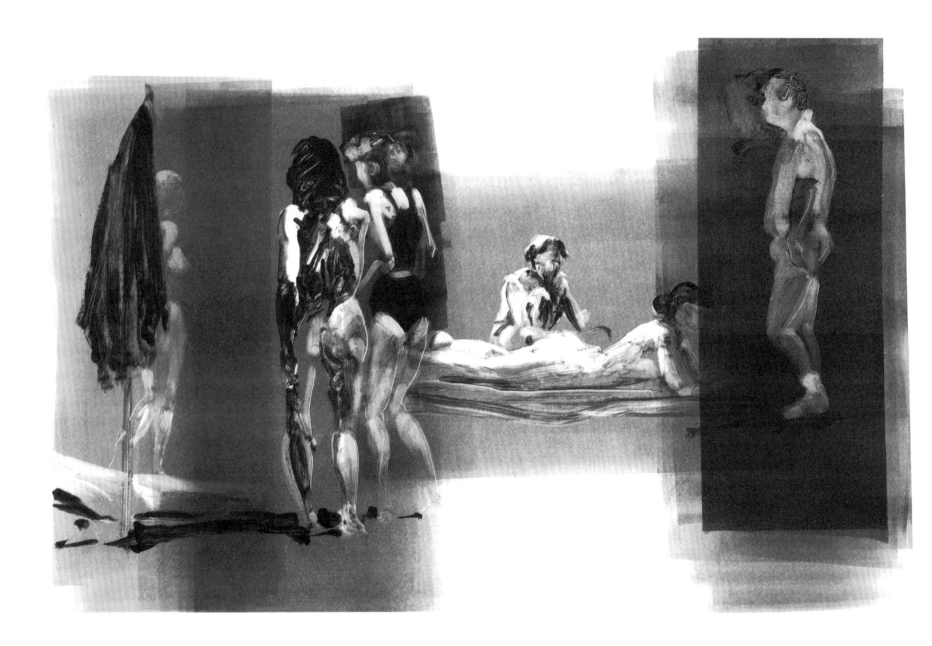

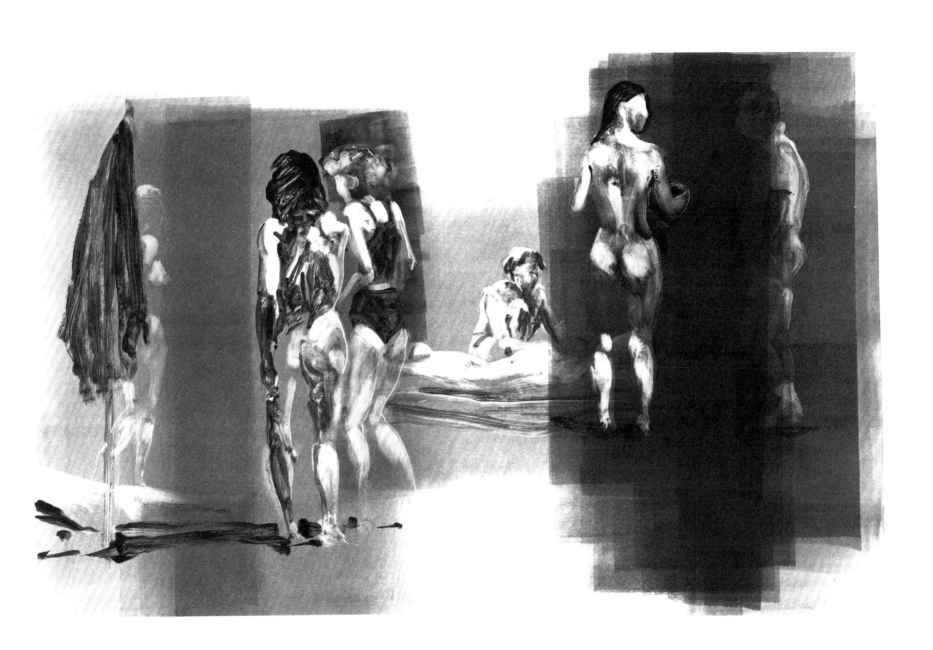

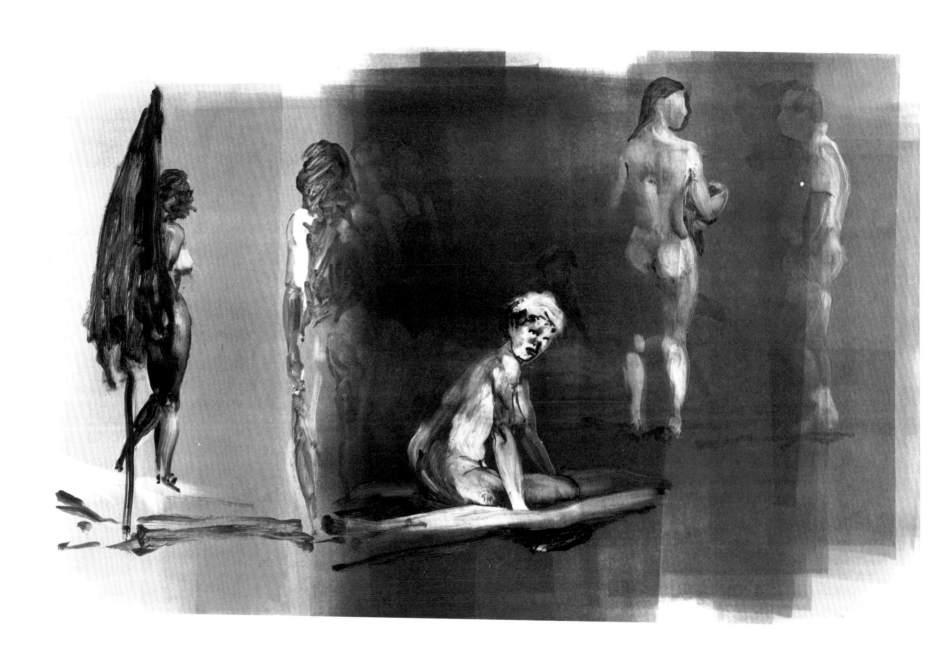

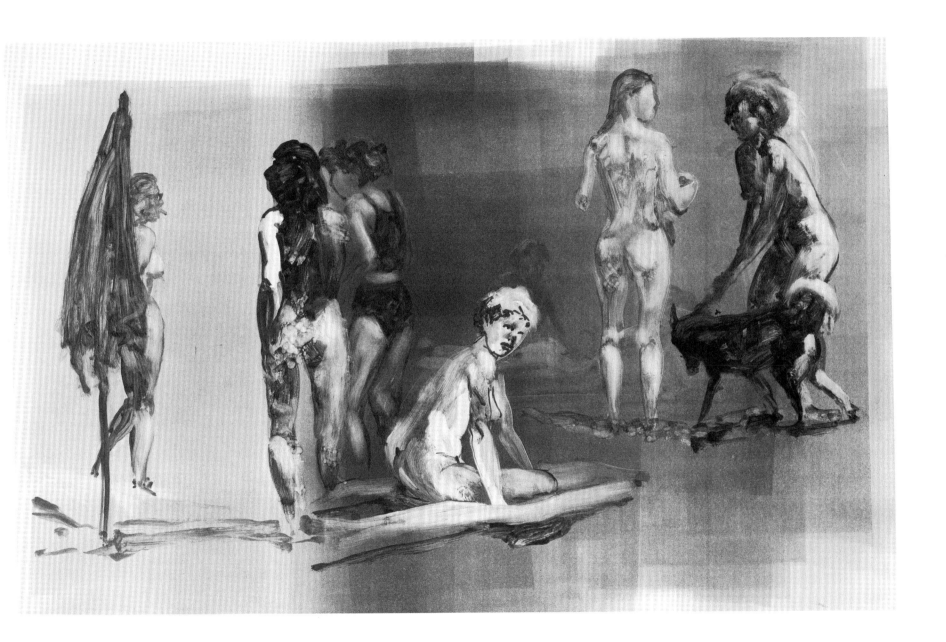

In March 1986, at the invitation of publisher Peter Blum, Eric Fischl began making monotypes at Derrière L'Etoile Studios, the workshop of the master printer Maurice Sanchez. Over the next nine months, Fischl explored thirteen narrative subjects for which he eventually produced 144 monotypes. From these, Blum chose fifty-eight for reproduction in a deluxe facsimile, book-length publication of the thirteen monotype series, entitled *Scenes and Sequences*. The book, which also included a prose text by E.L. Doctorow, was published in December 1989.

On the following pages we illustrate all 144 monotypes in three sections. The first section reproduces in color the fifty-eight monotypes included in the facsimile edition *Scenes and Sequences* and presented in the exhibition. Each of the thirteen series into which they are grouped is prefaced by its title and date of execution. The second section (nos. 59–113) includes monotypes from these same thirteen series that were not selected for publication in the facsimile edition. Again, each series is prefaced by its title and date of execution. The remaining thirty-one monotypes reproduced in the final section (nos. 114–144) were made during this campaign, but do not specifically relate to the thirteen series published in *Scenes and Sequences*. We have grouped these prints by theme and have assigned each of these "series" a descriptive title.

Complete checklist information follows the reproductions of the monotypes. Each entry for the thirteen series given titles by the artist (nos. 1–113) and published in part in the facsimile edition is accompanied by a number in parentheses. These numbers indicate the order in which the prints were produced in each series, and will enable the reader to reconstruct more accurately the artist's working process.

Stroll [March 1, 1986]

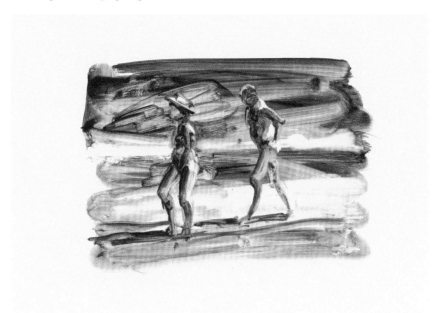

1

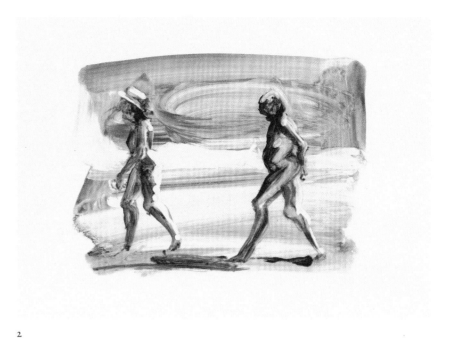

2

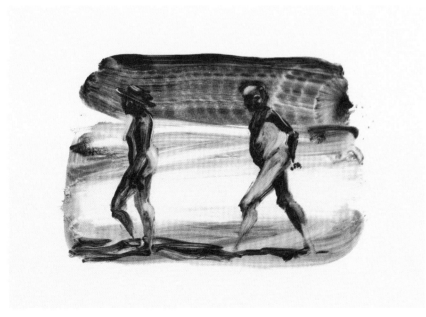

3

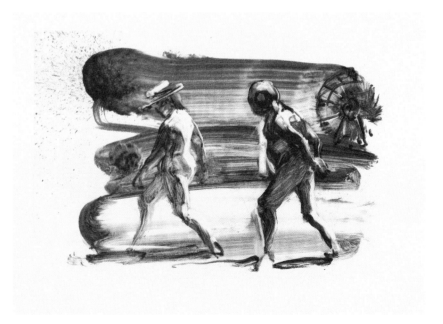

4

Voodoo [March 11, 1986]

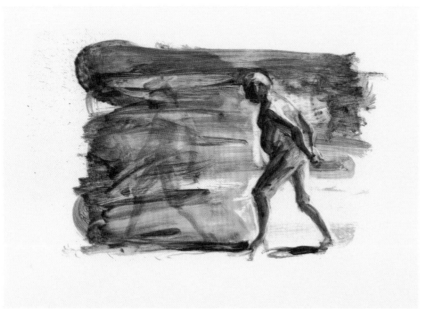

5

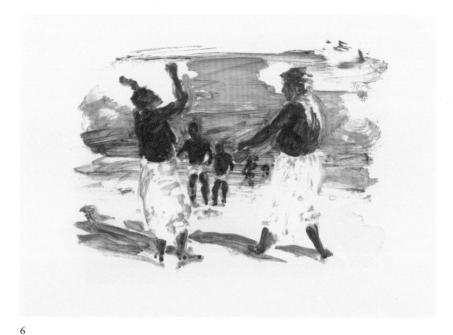

6

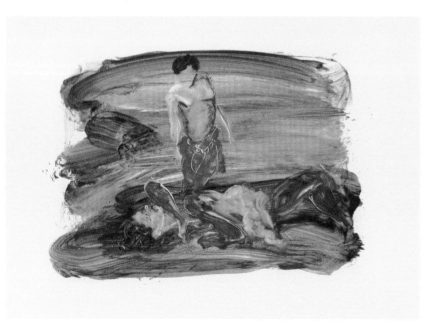

7

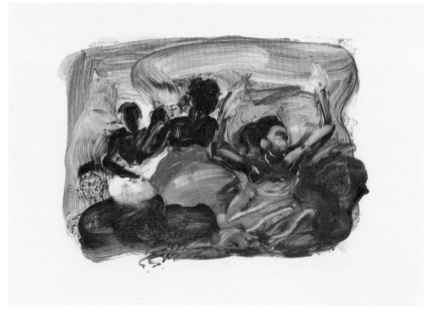

8

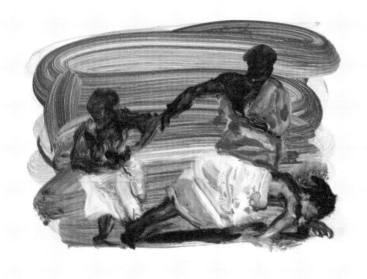

9

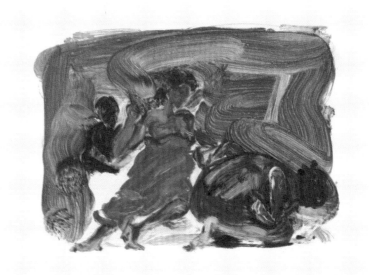

10

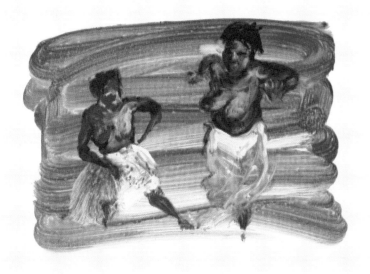

11

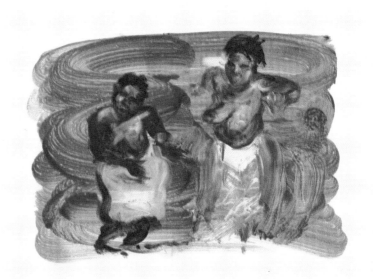

12

Vision [March 13, 1986]

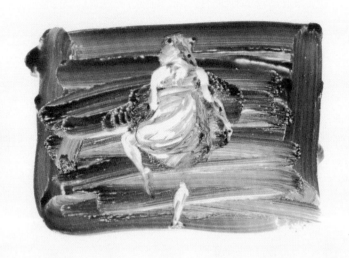

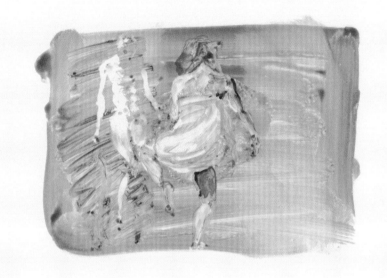

13

14

Dance [November 21, 1986]

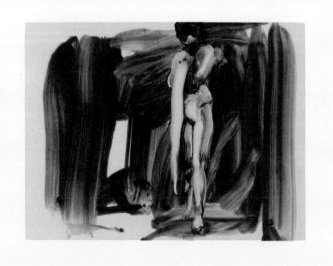

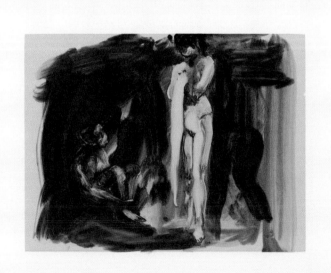

15

16

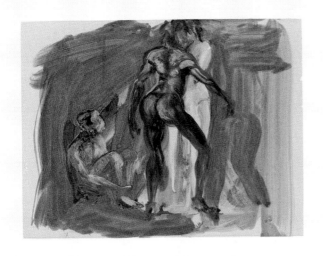

17

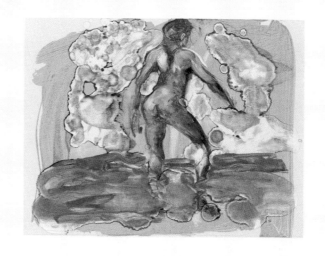

18

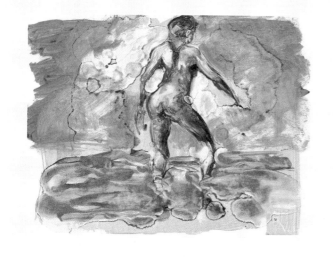

19

20

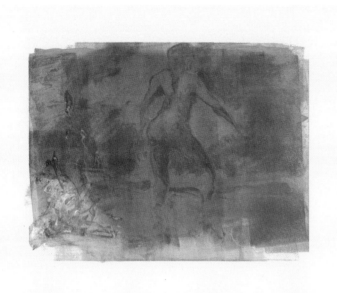

21

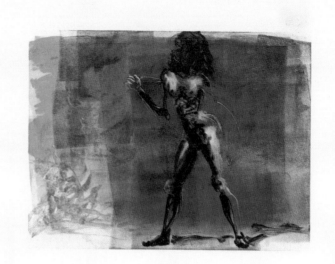

22

Companion [November 13, 1986]

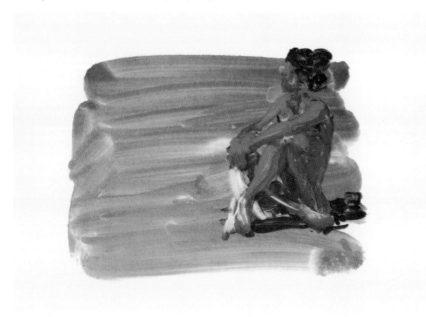

23

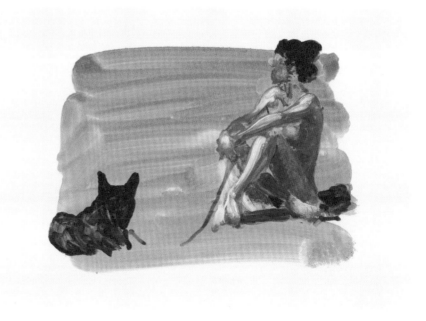

24

Specter [November 13, 1986]

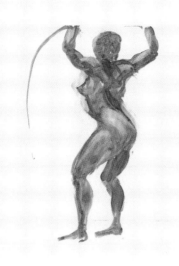

25

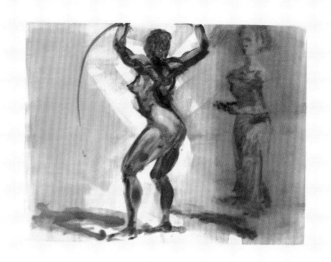

26

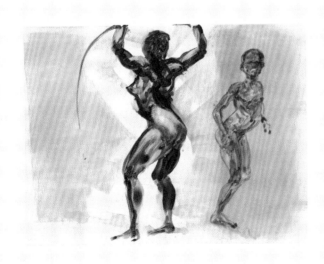

27

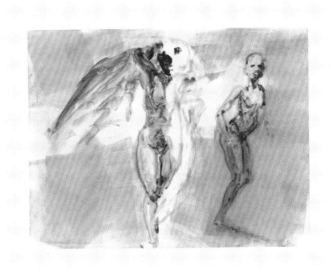

28

85

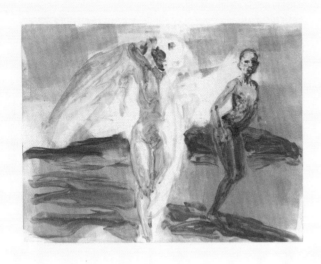

29

30

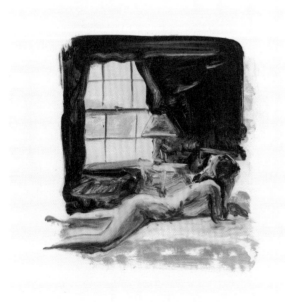

31

32

Girl [November 3, 1986]

33

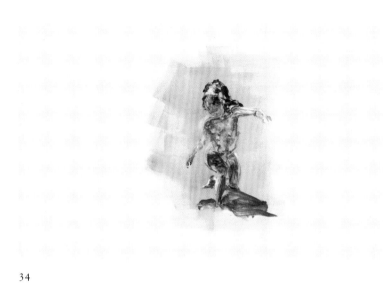

34

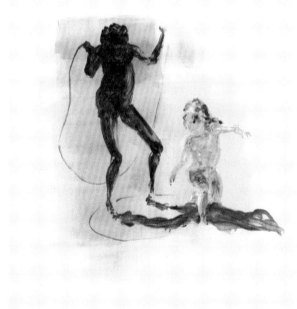

35

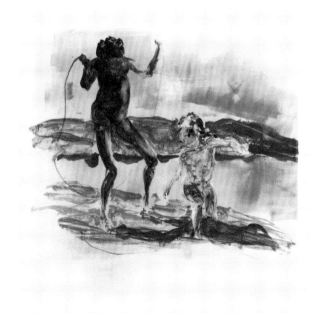

36

Backyard [December 10, 1986]

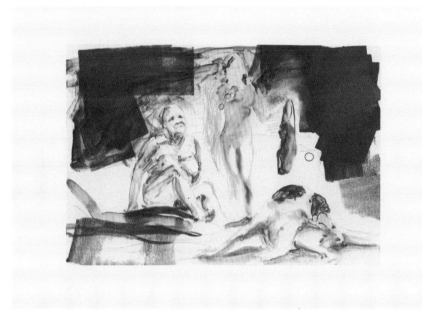

37

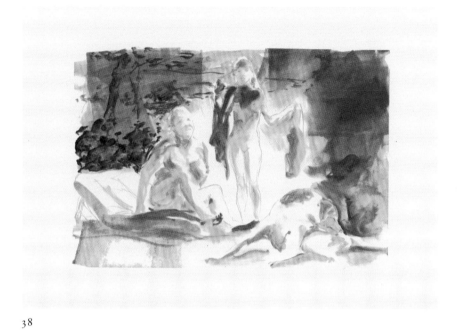

38

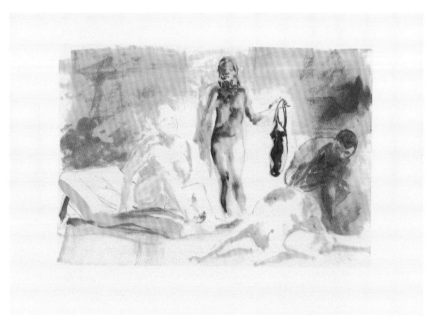

39

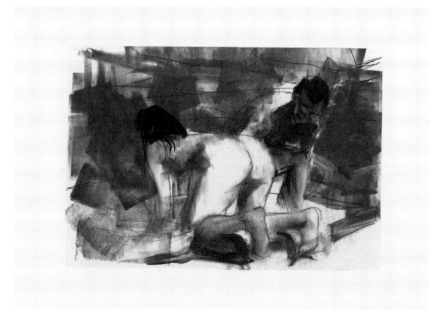

40

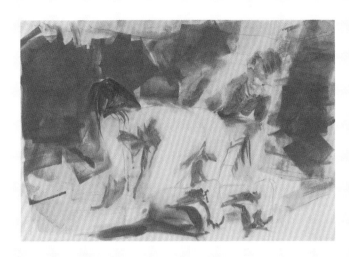

41

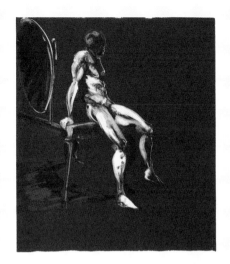

42

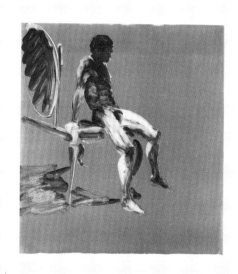

43

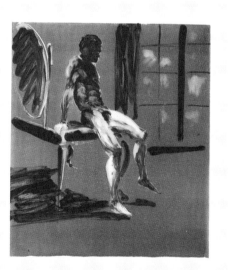

44

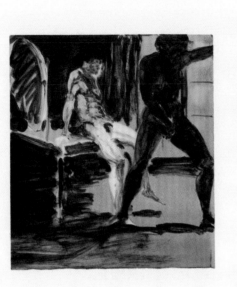

45

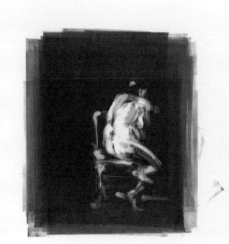

46

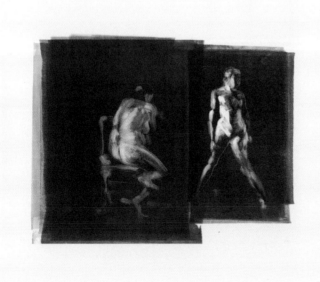

47

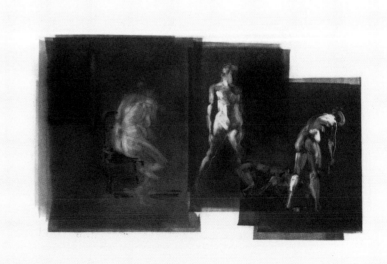

48

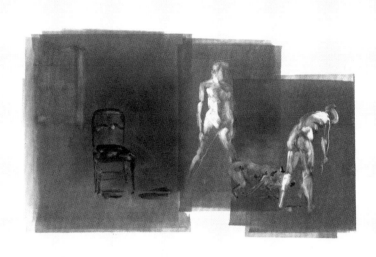

49

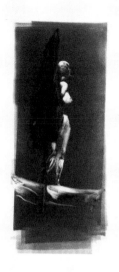

50

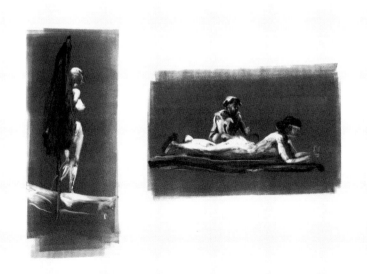

51

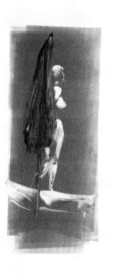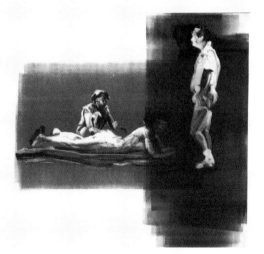

52

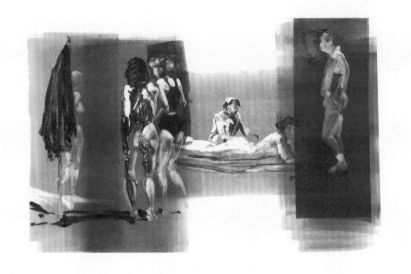

53

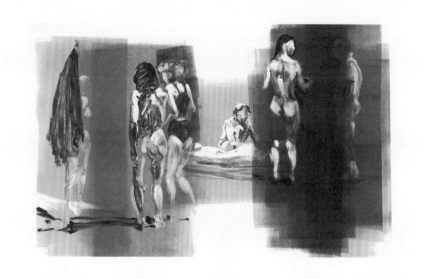

54

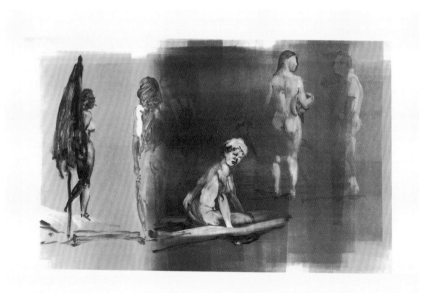

55

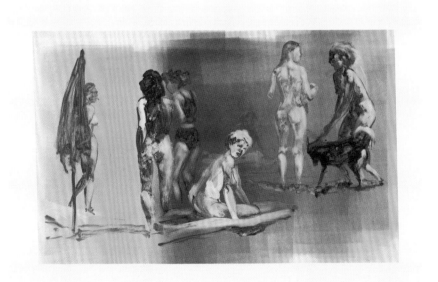

56

92

Boy [April 22, 1986]

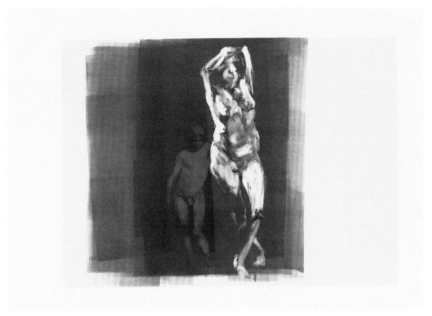

57

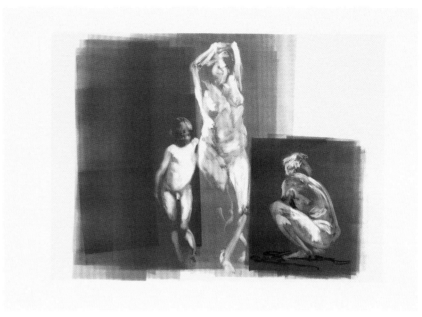

58

Stroll [March 1, 1986]

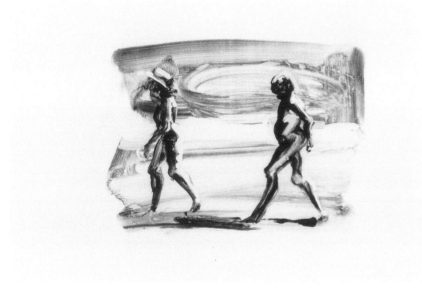

59

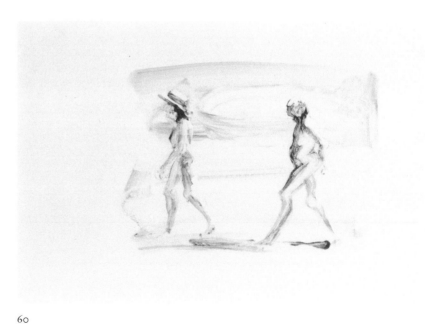

60

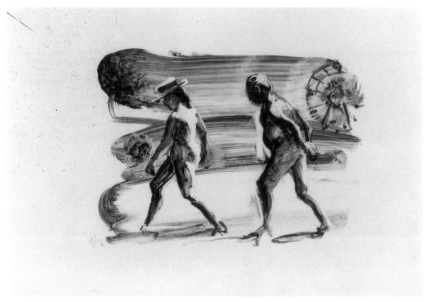

61

62

Voodoo [March 11, 1986]

63

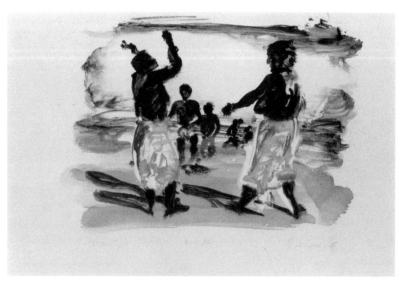

64

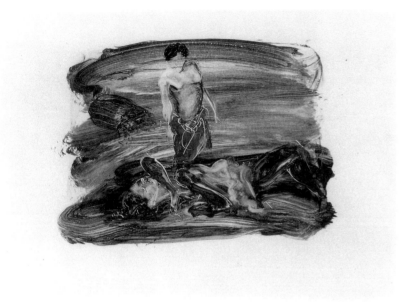

65

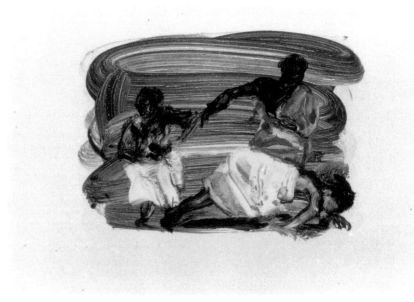

66

Vision [March 13, 1986]

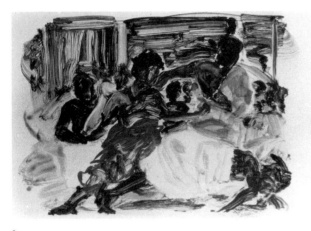

67

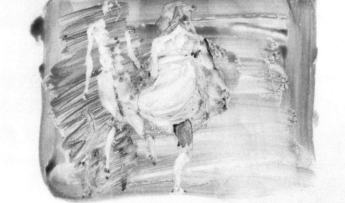

68

Companion [November 13, 1986]

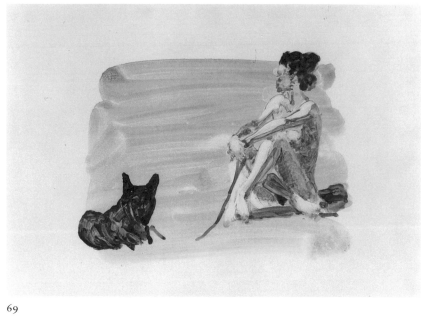

69

Specter [November 13, 1986]

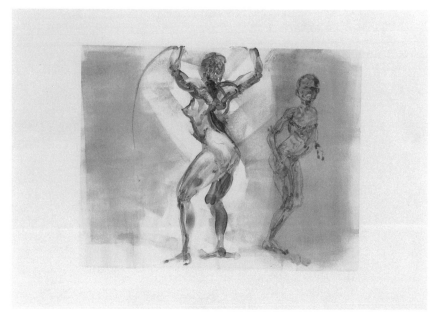

70

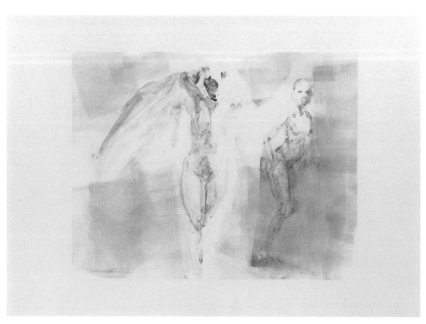

71

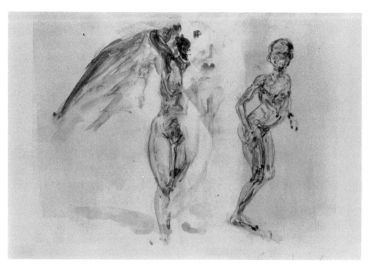

72

Dream [March 19, 1986]

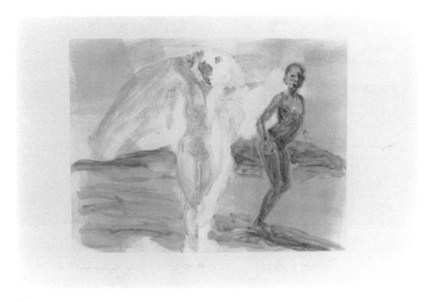

73

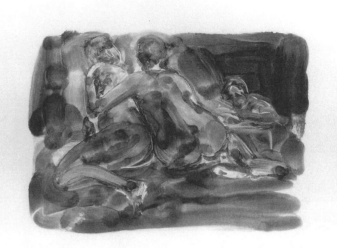

74

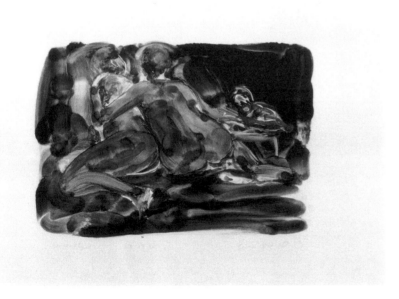

75

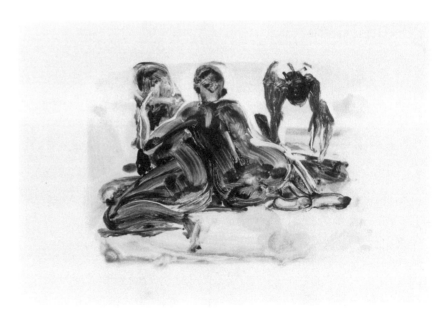

76

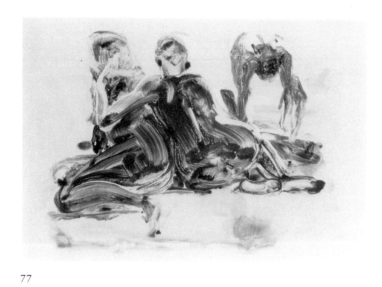

77

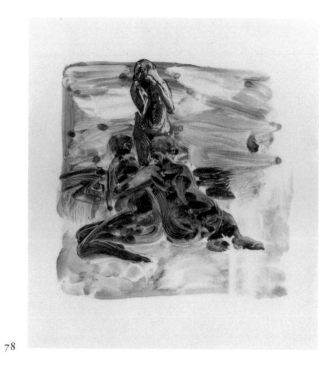

78

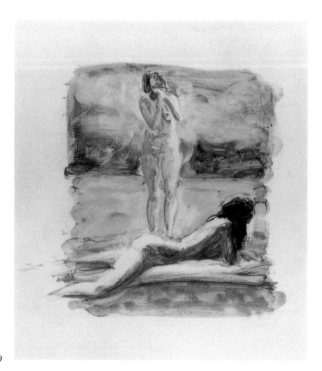

79

80

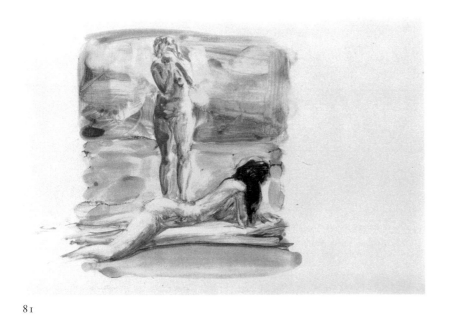

81

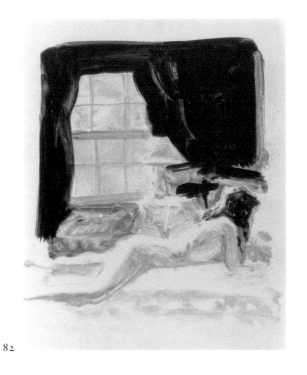

82

Girl [November 3, 1986]

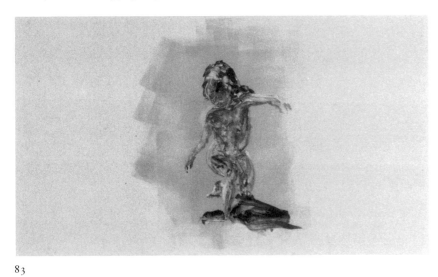

83

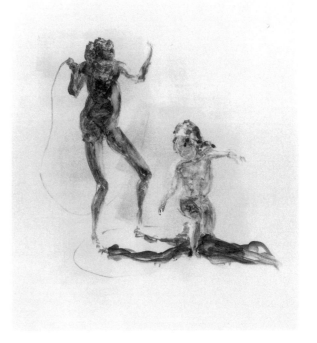

84

Backyard [December 10, 1986]

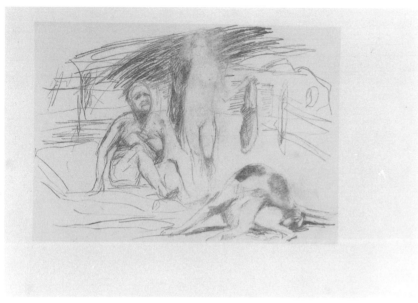

85

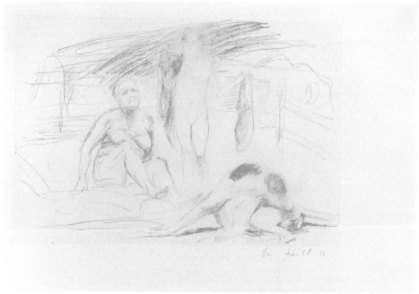

86

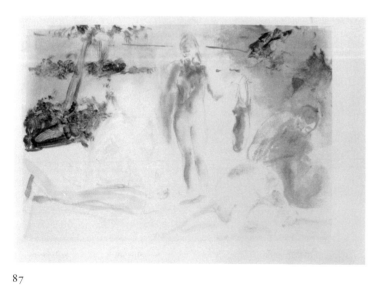

87

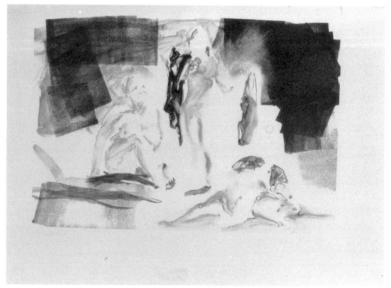

88

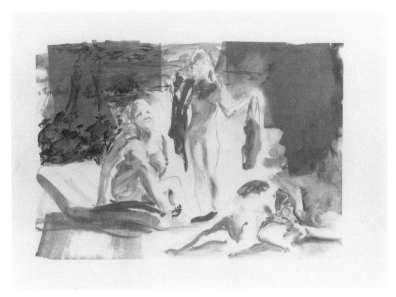

89

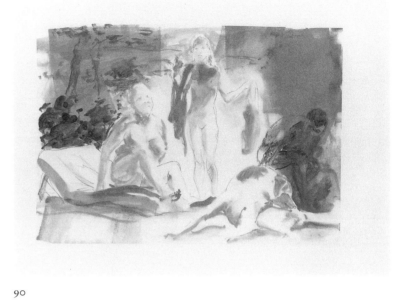

90

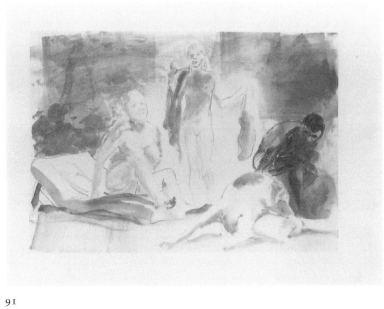

91

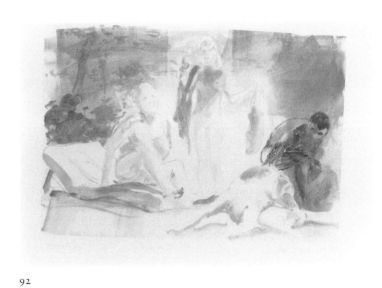

92

93

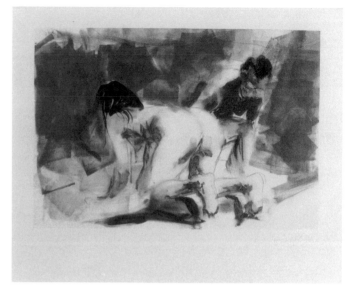

94

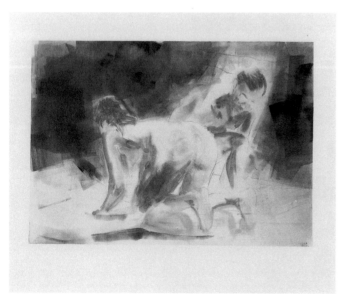

95

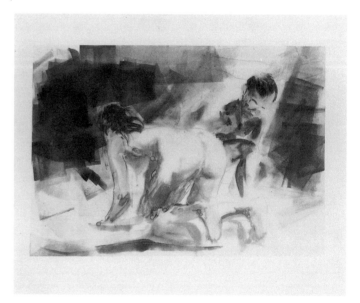

96

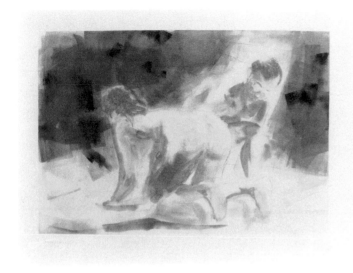

97

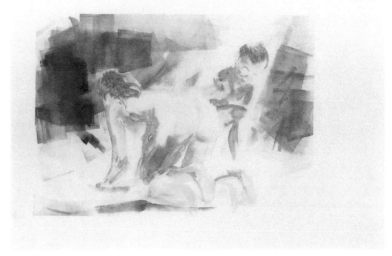

98

Man [April 12, 1986]

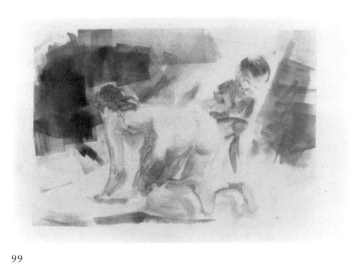

99

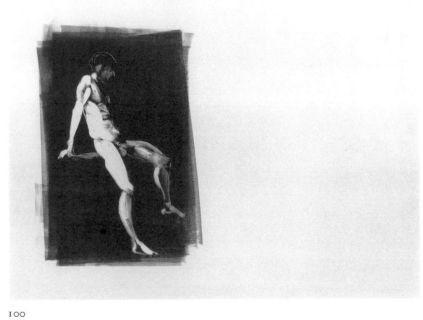

100

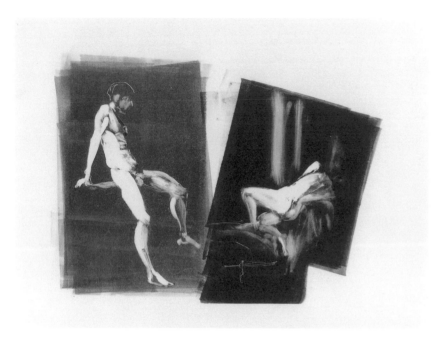

101

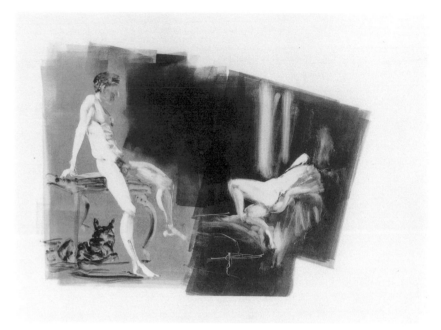

102

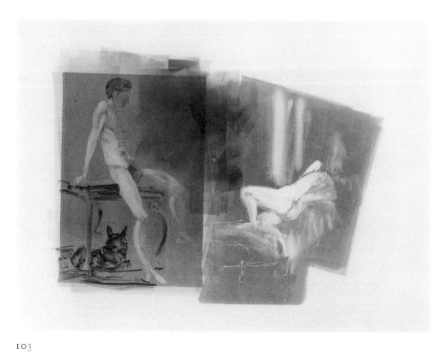

103

104

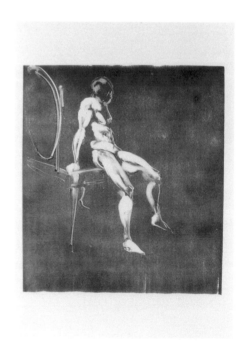

104

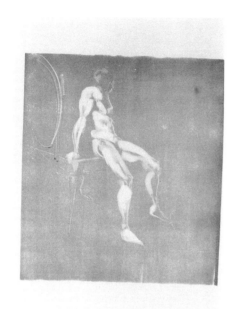

105

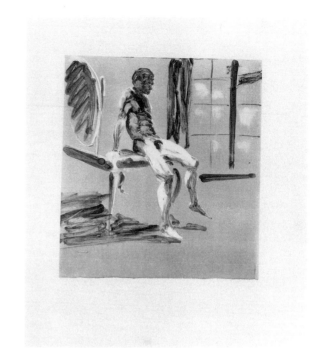

106

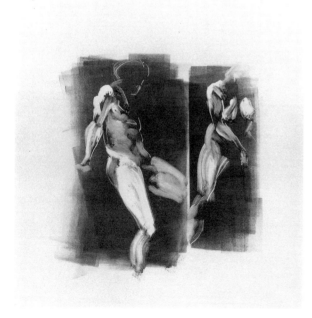

107

Fable [April 6, 1986]

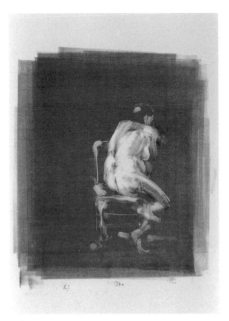

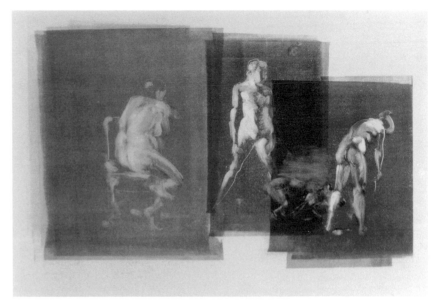

108

109

Beach [April 22, 1986]

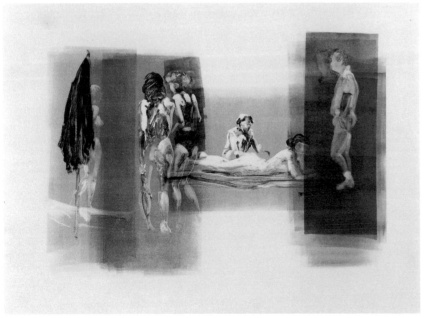

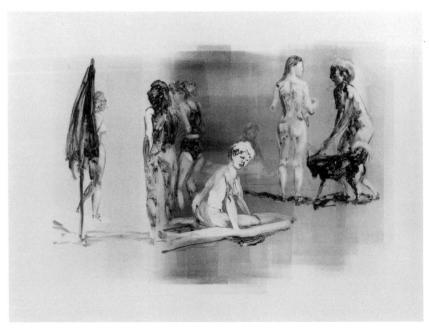

110

111

Boy [April 22, 1986]

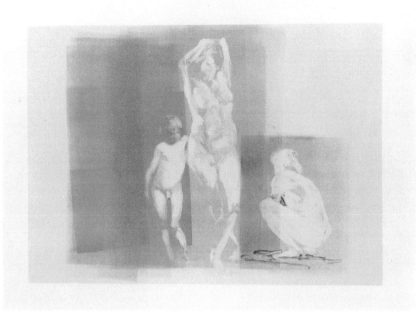

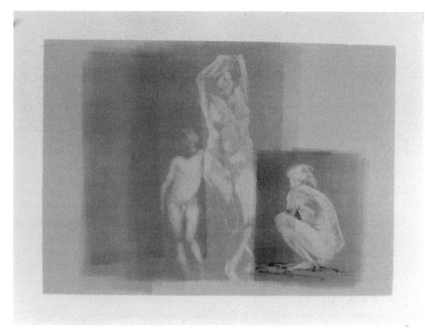

112

113

Dog Into Bathers

114

115

116

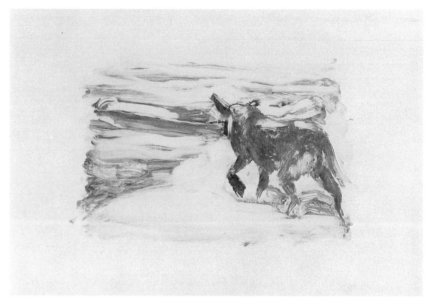

117

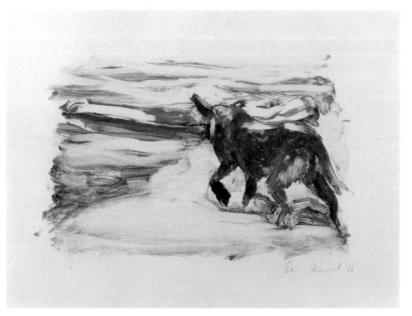

118

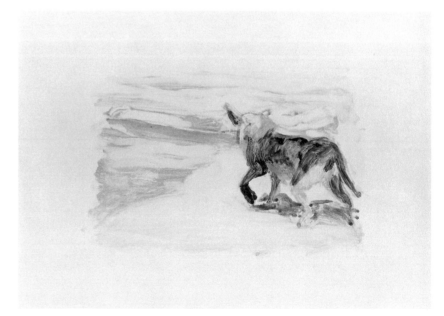

119

108

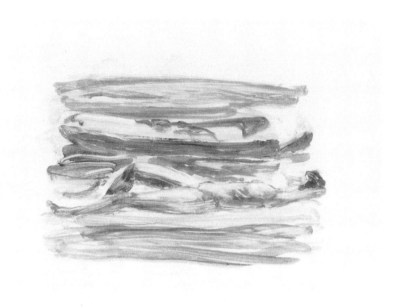

120

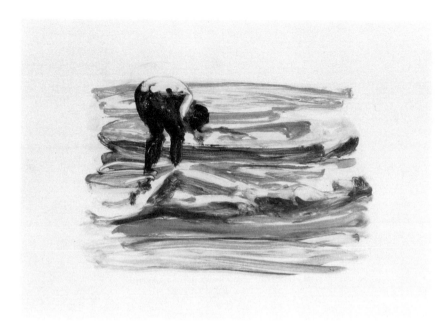

121

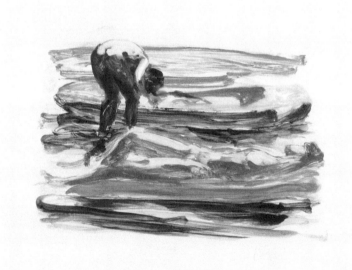

122

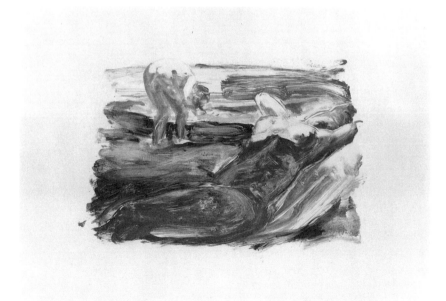

123

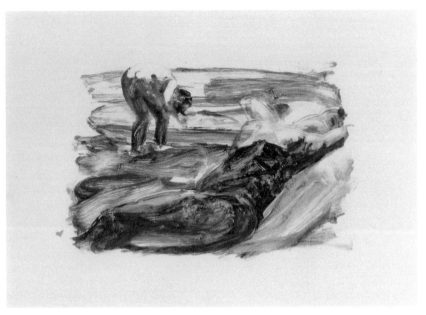

124

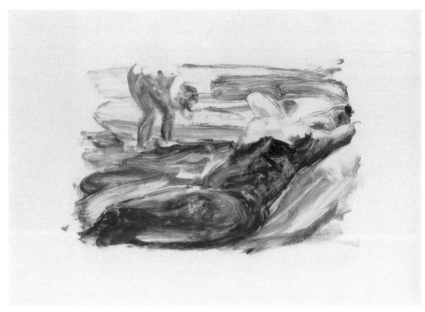

125

Bathers

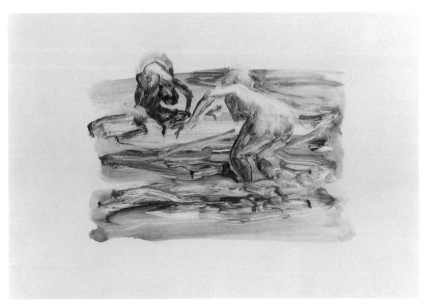

126

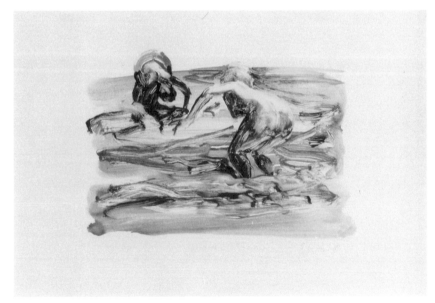

127

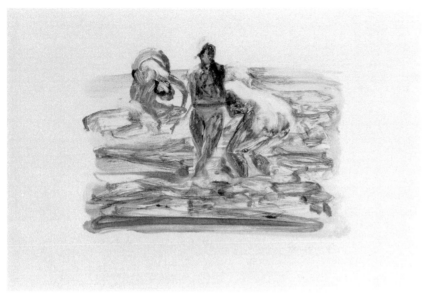

128

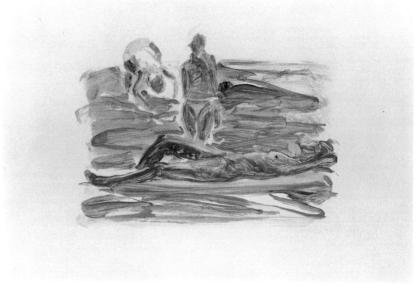

129

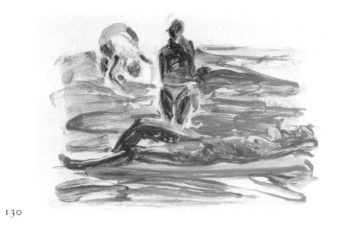

130

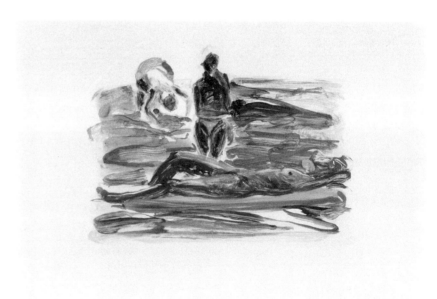

131

III

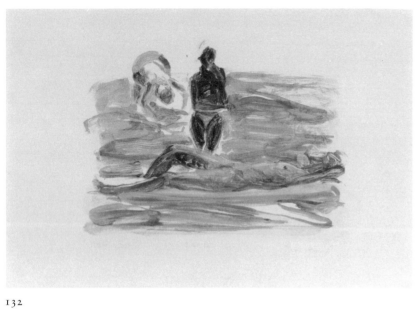

132

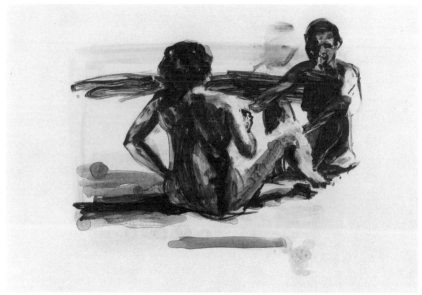

133

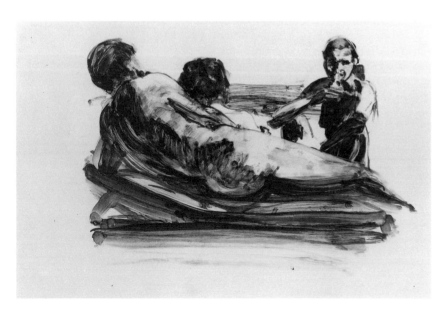

134

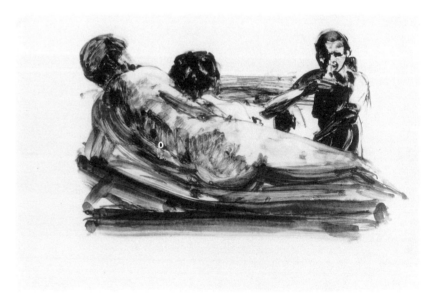

135

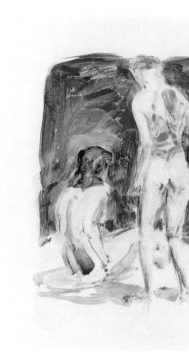

136

137

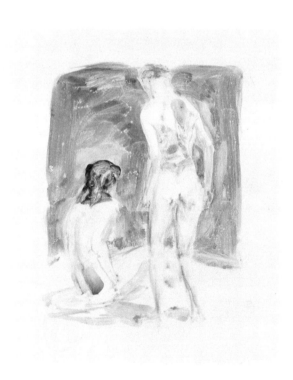

138

139

Figures on a Beach

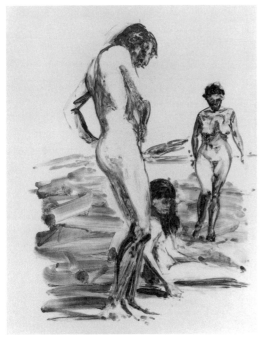

140

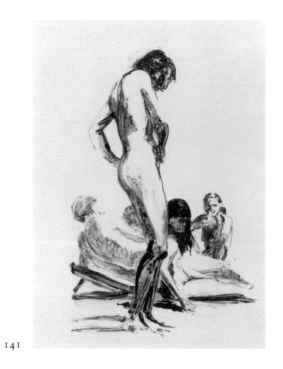

141

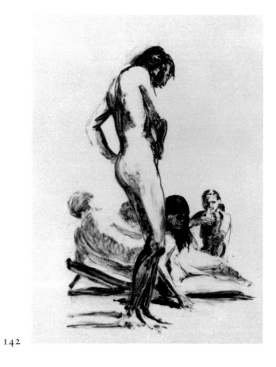

142

Figures in an Interior

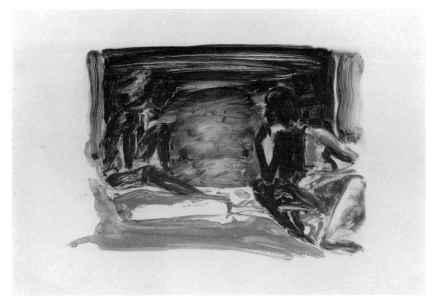

143

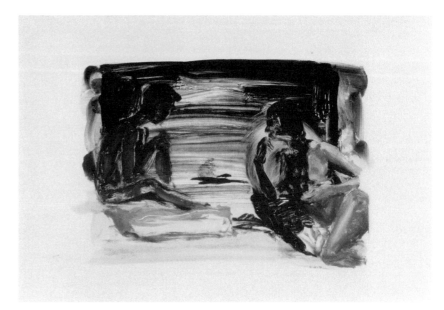

144

I. Monotypes included in the facsimile edition, *Scenes and Sequences*

Stroll [March 1, 1986]

1. *Untitled* (1)
 15½ x 22½
 Collection Paine Webber, New York

2. *Untitled* (3)
 14¾ x 22½
 Collection Paine Webber, New York

3. *Untitled* (5)
 15½ x 22½
 Collection Paine Webber, New York

4. *Untitled* (7)
 15⅛ x 22½
 Collection Paine Webber, New York

5. *Untitled* (8)
 15⅛ x 22½
 Collection Paine Webber, New York

Voodoo [March 11, 1986]

6. *Untitled* (2)
 15⅛ x 22½
 Collection Paine Webber, New York

7. *Untitled* (4)
 15⅛ x 22½
 Collection Paine Webber, New York

8. *Untitled* (5)
 15⅛ x 22½
 Collection Paine Webber, New York

9. *Untitled* (6)
 15⅛ x 22½
 Collection the artist

10. *Untitled* (9)
 15⅛ x 22½
 Collection Paine Webber, New York

11. *Untitled* (10)
 15⅛ x 22½
 Collection Paine Webber, New York

12. *Untitled* (11)
 15⅛ x 22½
 Collection the artist

Vision [March 13, 1986]

13. *Untitled* (1)
 15⅛ x 22½
 Collection the artist

14. *Untitled* (3)
 15⅛ x 22½
 Collection the artist

Dance [November 21, 1986]

15. *Untitled* (1)
 14½ x 20¼
 Collection Paine Webber, New York

16. *Untitled* (2)
 14⅝ x 20⅜
 Collection Paine Webber, New York

17. *Untitled* (3)
 14½ x 20¼
 Collection Paine Webber, New York

18. *Untitled* (4)
 14⅝ x 20¼
 Collection the artist

19. *Untitled* (5)
 14½ x 20⅜
 Collection the artist

20. *Untitled* (6)
 14½ x 20¼
 Collection the artist

21. *Untitled* (7)
 14⅝ x 17⅜
 Collection the artist

22. *Untitled* (8)
 14⅝ x 20¼
 Collection the artist

Companion [November 13, 1986]

23. *Untitled* (1)
 15 x 22½
 Collection the artist

24. *Untitled* (2)
 15⅛ x 22½
 Collection Paine Webber, New York

Specter [November 13, 1986]

25. *Untitled* (1)
 16 x 20¼
 Collection the artist

26. *Untitled* (2)
 16⅛ x 20¼
 Collection the artist

27. *Untitled* (4)
 14⅝ x 20¼
 Collection the artist

28. *Untitled* (5)
 16 x 20⅛
 Collection Paine Webber, New York

29. *Untitled* (8)
 18½ x 28
 Collection Paine Webber, New York

Dream [March 19, 1986]

30. *Untitled* (8)
 22½ x 25¼
 Collection Paine Webber, New York

31. *Untitled* (10)
 22½ x 25¼
 Collection Paine Webber, New York

32. *Untitled* (11)
 22½ x 25¼
 Collection the artist

Girl [November 3, 1986]

33. *Untitled* (1)
 18½ x 28¼
 Collection the artist

34. *Untitled* (2)
 15 x 29¾
 Collection the artist

35. *Untitled* (4)
 19¾ x 21½
 Collection the artist

36. *Untitled* (6)
 19¾ x 21⅝
 Collection the artist

Backyard [December 10, 1986]

37. *Untitled* (3)
 15 x 20
 Collection the artist

38. *Untitled* (7)
 19⅜ x 21
 Collection the artist

39. *Untitled* (10)
 20 x 21½
 Collection Paine Webber, New York

40. *Untitled* (12)
20¼ x 22⅛
Collection Paine Webber, New York

41. *Untitled* (20)
20⅛ x 22
Collection Paine Webber, New York

Man [April 12, 1986]

42. *Untitled* (5)
25⅛ x 22½
Collection Paine Webber, New York

43. *Untitled* (8)
25⅛ x 22½
Collection the artist

44. *Untitled* (9)
25⅛ x 22½
Collection the artist

45. *Untitled* (11)
25⅛ x 22½
Collection the artist

Fable [April 16, 1986]

46. *Untitled* (1)
25 x 34½
Collection the artist

47. *Untitled* (3)
25 x 34½
Collection the artist

48. *Untitled* (4)
25 x 34⅝
Collection the artist

49. *Untitled* (6)
25 x 34½
Collection the artist

Beach [April 22, 1986]

50. *Untitled* (1)
25 x 34½
Private Collection

51. *Untitled* (2)
25 x 34½
Private Collection

52. *Untitled* (3)
25 x 34⅜
Private Collection

53. *Untitled* (5)
25 x 35⅝
Private Collection

54. *Untitled* (6)
25 x 34⅝
Private Collection

55. *Untitled* (7)
25⅛ x 34½
Private Collection

56. *Untitled* (9)
25 x 34½
Private Collection

Boy [April 22, 1986]

57. *Untitled* (1)
25 x 34½
Collection the artist

58. *Untitled* (2)
25 x 34⅝
Collection the artist

II. Monotypes not included in the facsimile edition, *Scenes and Sequences*

Stroll [March 1, 1986]

59. *Untitled* (2)
15 x 22½
Courtesy Mary Boone Gallery
Private Collection

60. *Untitled* (4)
15 x 22½
Courtesy Mary Boone Gallery
Collection Jean McCusker, Nevada

61. *Untitled* (6)
15⅙ x 22⅜
Collection the artist

62. *Untitled* (9)
15⅛ x 22⁷⁄₁₆
Collection the artist

63. *Untitled* (10)
15³⁄₁₆ x 22⅜
Collection the artist

Voodoo [March 11, 1986]

64. *Untitled* (1)
15 x 22½
Courtesy Mary Boone Gallery
Collection Thomas Ammann, Zurich

65. *Untitled* (3)
15⅛ x 22⅛
Collection the artist

66. *Untitled* (7)
15 x 22¼
Collection Derrière L'Etoile Studios

67. *Untitled* (8)
15½ x 22½
Courtesy G.H. Dalsheimer Gallery

Vision [March 13, 1986]

68. *Untitled* (2)
15⅙ x 23³⁄₁₆
Collection the artist

Companion [November 13, 1986]

69. *Untitled* (3)
15 x 22⅜
Collection the artist

Specter [November 13, 1986]

70. *Untitled* (3)
16 x 20¼
Collection the artist

71. *Untitled* (6)
16 x 20
Collection the artist

72. *Untitled* (7)
14¹¹⁄₁₆ x 20¼
Courtesy G. H. Dalsheimer Gallery

73. *Untitled* (9)
18½ x 28
Courtesy Mary Boone Gallery
Collection Thomas Ammann, Zurich

Dream [March 19, 1986]

74. *Untitled* (1)
15⅛ x 22⅝
Collection the artist

75. *Untitled* (2)
15 x 22½
Courtesy Mary Boone Gallery
Collection Karen Meyerhoff, Boston

76. *Untitled* (3)
15 x 22½
Courtesy Mary Boone Gallery
Collection George Dalsheimer, Baltimore

77. *Untitled* (4)
15 x 22½
Courtesy G.H. Dalsheimer Gallery

78. *Untitled* (5)
22½ x 25⅛
Collection the artist

79. *Untitled* (6)
22½ x 25⅛
Collection the artist

80. *Untitled* (7)
22½ x 25⅛
Courtesy G.H. Dalsheimer Gallery

81. *Untitled* (9)
22½ x 25
Courtesy Mary Boone Gallery
Collection Thomas Ammann, Zurich

82. *Untitled* (12)
22½ x 30
Courtesy Mary Boone Gallery
Collection Thomas Ammann, Zurich

Girl [November 3, 1986]

83. *Untitled* (3)
15 x 22¼
Collection Derrière L'Etoile Studios

84. *Untitled* (5)
19¾ x 21½
Collection the artist

Backyard [December 10, 1986]

85. *Untitled* (1)
15 x 22½
Collection the artist

86. *Untitled* (2)
15 x 22¼
Courtesy Van Straaten Gallery

87. *Untitled* (4)
20 x 22½
Courtesy Mary Boone Gallery
Private Collection

88. *Untitled* (5)
20 x 22½
Courtesy Mary Boone Gallery
Private Collection

89. *Untitled* (6)
19⁷⁄₁₆ x 20⅞
Collection the artist

90. *Untitled* (8)
19½ x 21
Collection the artist

91. *Untitled* (9)
20 x 20½
Collection the artist

92. *Untitled* (11)
20 x 22½
Courtesy Mary Boone Gallery
Collection Michael Maloney,
Santa Monica

93. *Untitled* (13)
22 x 22½
Courtesy Mary Boone Gallery
Collection Jean McCusker, Nevada

94. *Untitled* (14)
17¾ x 19
Collection Derrière L'Etoile Studios

95. *Untitled* (15)
22 x 22⅛
Collection the artist

96. *Untitled* (16)
20¼ x 22¼
Collection the artist

97. *Untitled* (17)
20⅛ x 22¼
Courtesy Mary Boone Gallery
Collection Thomas Ammann, Zurich

98. *Untitled* (18)
21¾ x 22
Collection the artist

99. *Untitled* (19)
22 x 22½
Courtesy Mary Boone Gallery
Private Collection

Man [April 12, 1986]

100. *Untitled* (1)
25 x 34½
Collection the artist

101. *Untitled* (2)
25 x 34½
Collection the artist

102. *Untitled* (3)
25 x 34½
Collection the artist

103. *Untitled* (4)
25 x 34½
Collection the artist

104. *Untitled* (6)
25 x 22½
Courtesy Mary Boone Gallery
Private Collection

105. *Untitled* (7)
25 x 22½
Courtesy Mary Boone Gallery
Private Collection

106. *Untitled* (10)
25³⁄₁₆ x 22½
Collection the artist

107. *Untitled* (12)
19⅙ x 22⅜
Collection the artist

Fable [April 16, 1986]

108. *Untitled* (2)
25 x 34
Courtesy Mary Boone Gallery
Private Collection

109. *Untitled* (5)
25 x 34
Courtesy Mary Boone Gallery
Collection George Dalsheimer,
Baltimore

Beach [April 22, 1986]

110. *Untitled* (4)
25 x 34½
Collection E.L. Doctorow

111. *Untitled* (8)
25 x 34½
Collection the artist

Boy [April 22, 1986]

112. *Untitled* (3)
25⅛ x 34
Collection the artist

113. *Untitled* (4)
25⅛ x 33
Courtesy Lorence Monk Gallery

III. Monotypes not included in the *Scenes and Sequences* series

Dog Into Bathers

114. *Untitled*
15¹/₁₆ x 21¹/₁₆
Collection the artist

115. *Untitled*
15 x 22½
Courtesy Mary Boone Gallery
Collection Thomas Ammann, Zurich

116. *Untitled*
15 x 22¼
Collection Derrière L'Etoile Studios

117. *Untitled*
15 x 22⅜
Collection the artist

118. *Untitled*
15 x 22¼
Courtesy Van Straaten Gallery

119. *Untitled*
15 x 22⁷/₁₆
Collection the artist

120. *Untitled*
15 x 22½
Courtesy Mary Boone Gallery
Collection Barbara Guggenheim,
New York

121. *Untitled*
15 x 22¼
Collection Derrière L'Etoile Studios

122. *Untitled*
15 x 22½
Courtesy Mary Boone Gallery
Collection Eugene Stevens, Ohio

123. *Untitled*
15½ x 22
Collection the artist

124. *Untitled*
15 x 22½
Courtesy Mary Boone Gallery
Collection Karen Meyerhoff, Boston

125. *Untitled*
15 x 22½
Courtesy Mary Boone Gallery
Collection Ake Skeppner, New York

Bathers

126. *Untitled*
15 x 22³/₁₆
Collection the artist

127. *Untitled*
15 x 22½
Courtesy Mary Boone Gallery
Collection Marsha and Bruce Fogel,
New York

128. *Untitled*
15 x 22½
Courtesy Mary Boone Gallery
Collection Thomas Ammann, Zurich

129. *Untitled*
15 x 22¼
Collection the artist

130. *Untitled*
15 x 22½
Courtesy G.H. Dalsheimer Gallery

131. *Untitled*
15 x 22½
Courtesy Mary Boone Gallery
Collection George Dalsheimer,
Baltimore

132. *Untitled*
15 x 22½
Courtesy Mary Boone Gallery
Collection Marsha and Bruce Fogel,
New York

Seated Figures on a Beach

133. *Untitled*
15 x 22
Collection the artist

134. *Untitled*
15 x 22
Collection the artist

135. *Untitled*
15 x 22
Collection Derrière L'Etoile Studios

136. *Untitled*
15 x 22
Collection the artist

Two Figures on a Beach

137. *Untitled*
22½ x 15⅛
Collection the artist

138. *Untitled*
22½ x 15
Courtesy Mary Boone Gallery
Collection Lawrence and Mickey
Beyer, Ohio

139. *Untitled*
22½ x 15
Courtesy G. H. Dalsheimer Gallery

Figures on a Beach

140. *Untitled*
30¼ x 22
Collection the artist

141. *Untitled*
30 x 22
Collection Derrière L'Etoile Studios

142. *Untitled*
30 x 22½
Courtesy Mary Boone Gallery
Collection Thomas Ammann, Zurich

Figures in an Interior

143. *Untitled*
15 x 22½
Collection the artist

144. *Untitled*
15 x 22½
Courtesy Mary Boone Gallery
Collection Thomas Ammann, Zurich

SCENES AND SEQUENCES

has been composed and printed by Meriden-Stinehour Press, Lunenburg, Vermont. The typeface used throughout is Sabon and the text paper is Monadnock Dulcet. The binding is by Acme Bookbinding, Charlestown, Massachusetts.

Design by Christopher Kuntze